THE ART OF
VAN GOGH

THE ART OF
VAN GOGH

Nathaniel Harris

GALLERY BOOKS
An Imprint of W. H. Smith Publishers Inc.
112 Madison Avenue
New York City 10016

First published in Great Britain in 1982 by
The Hamlyn Publishing Group Limited

This edition published in 1989 by Gallery Books
an imprint of W.H. Smith Publishers Inc.
112 Madison Avenue, New York City 10016

Copyright © 1982 The Hamlyn Publishing Group Limited

ISBN 0-8317-9104-7

Produced by Mandarin Offset
Printed and bound in Hong Kong

Contents

The Greatness of Van Gogh

Artists have often been described as 'outsiders' – misunderstood and rejected men of genius, at odds with the world and with themselves. Like most such images, this one is no more than a partial truth; but if any man resembled that image, it was the Dutch painter, Vincent van Gogh. In worldly terms he was an utter failure – in business, as an evangelist, and finally in his true vocation as an artist. Of the 800 or so pictures he painted, only one was sold before his death. By the age of twenty-two he had become a life-long dependant, supported first by his parents and later by his devoted brother, Theo. Yet he laboured ceaselessly at his art, preferring to half-starve himself rather than go without the materials he needed for his work. Having abandoned the religion of his forefathers, he made a religion out of art, dedicating himself to it with the fanatical single-mindedness of an anchorite. At the same time, Van Gogh was tormented by loneliness: with a heart full of love for his fellow man, he was nevertheless too touchy and demanding to keep for very long any of the friends he made, while most of the respectable women he met seem to have been put off by the intensity of his need and his flagrant disregard of the conventions. Eventually, after years of endurance and neglect, Van Gogh broke down completely; while living at Arles, in the South of France, with his brother-artist Paul Gauguin, he made the sad, sick, confused and now famous gesture – he sliced off a piece of his ear and gave it to a local prostitute. The remaining months of his tragic life were spent under care until his suicide in July 1890, when he was only thirty-seven years old.

The posthumous continuation of the story follows the same course, like a romantic stereotype of the artist's fate. Immediately after Van Gogh's death, his work was still so little regarded that his brother found it impossible even to hold an exhibition in his memory; yet within a few years the dead man was on his way to becoming one of the most revered of the modern masters.

Van Gogh's entire career as an artist lasted no more than a decade. He took up drawing seriously in the summer of 1880, when he was already twenty-seven years old, after his failure as an evangelist among the miners of the Borinage in southern Belgium. Drawing continued to be his main preoccupation for another two years or more. During this period he was strongly motivated by the kind

Miners' Wives Carrying Sacks (also known as *The Bearers of the Burden*). Probably April 1881. Pen, pencil and brush study. While he was working as an evangelist in a Belgian mining district, Van Gogh's powerful social conscience was stirred by the exploitation of the men and their families. Rijksmuseum Kröller-Müller, Otterlo.

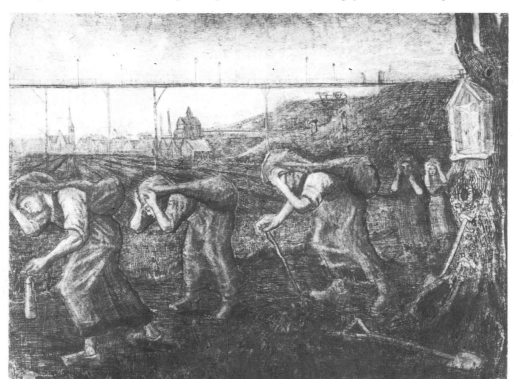

Right: *Self-portrait with Bandaged Ear*. 1889. A cruelly truthful self-portrait of Van Gogh after he had cut off a piece of his own ear in a fit of madness. Courtauld Institute Galleries, London.

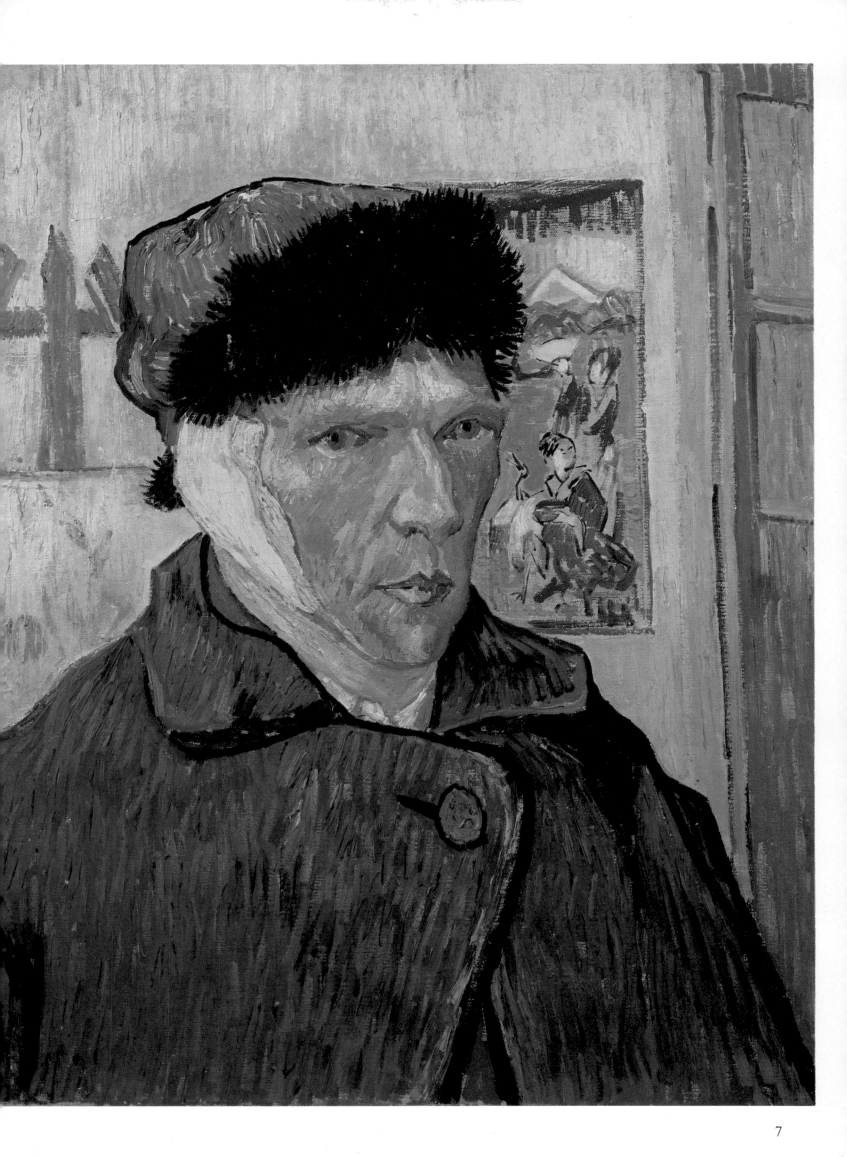

of humanitarian feelings that had attracted him to the ministry – in particular, by compassion for the hard lot of such 19th-century toilers as peasants, weavers, miners and fisher-folk. Significantly, Van Gogh admired writers such as Charles Dickens, Harriet Beecher Stowe, Victor Hugo and Emile Zola, in whom a social conscience was highly developed; and for a long time he modelled his work on relatively minor but sentimental-moralistic 'peasant paintings' by artists such as Jozef Israëls and Jean-François Millet.

Van Gogh produced some superb drawings in this vein, and also a number of striking paintings such as the famous *Potato Eaters*. But the works which put him among the great masters of his time were executed only during the last four years of his life, after he had left the Low Countries and settled – if he can ever be said to have settled anywhere – in France. There, despite opposition as vociferous as anything Van Gogh had encountered in Antwerp or at The Hague, an artistic revolution was already in full swing; led by the Impressionists, French artists were devising new techniques and working in bolder, brighter colours than 19th-century convention permitted.

In Paris, Van Gogh studied and absorbed these novelties, discovering in the process his own genius as a colourist. It was his passion for colour, as well as a characteristic reaction against big-city life, that prompted his move to Arles where for him, as for generations of northerners, the strong light and blazing colours of the Midi provided a transforming experience. Dazzled by everything he saw about him, yet racked by an inner anguish, Van Gogh developed an art of supreme emotional intensity. He did not merely attempt to paint what he saw: he painted what he felt. His work became a vision of the world and an

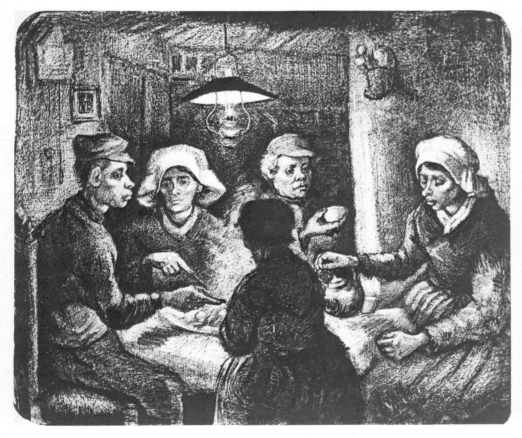

expression of the painter's soul and emotions. Instead of using colour realistically, he employed it, as he himself explained, 'more arbitrarily, in order to express myself more forcibly'. In a painting such as *The Night Café*, for example, red and green 'express the terrible passions of humanity', endowing a commonplace interior with a dully sordid, curiously dispiriting atmosphere. Van Gogh was equally audacious in distorting perspective and the shapes and proportions of objects in the interests of emotional expression. Even the texture of the paint became an element in the overall effect he sought, for Van Gogh built up his colours to an often extraordinary thickness (known as *impasto*); as a result, the completed picture stands out from the canvas like a relief, while the heavy brush-strokes form a visible pattern that fills the entire work with an insistent, hectic rhythm. In Van Gogh's late, hallucinatory paintings, cypresses take on a sinister, writhing quality, buildings buckle, and the sun, moon and stars are so

The Potato Eaters. 1885. Lithograph (above left) and painting (above) show Van Gogh's awareness of the narrow, brutalized lives led by the peasants; but the scene is also intended as a kind of Communion, indicating the spiritual value of labour. Lithograph: Rijksmuseum Kröller-Müller, Otterlo. Painting: Rijksmuseum Vincent van Gogh, Amsterdam.

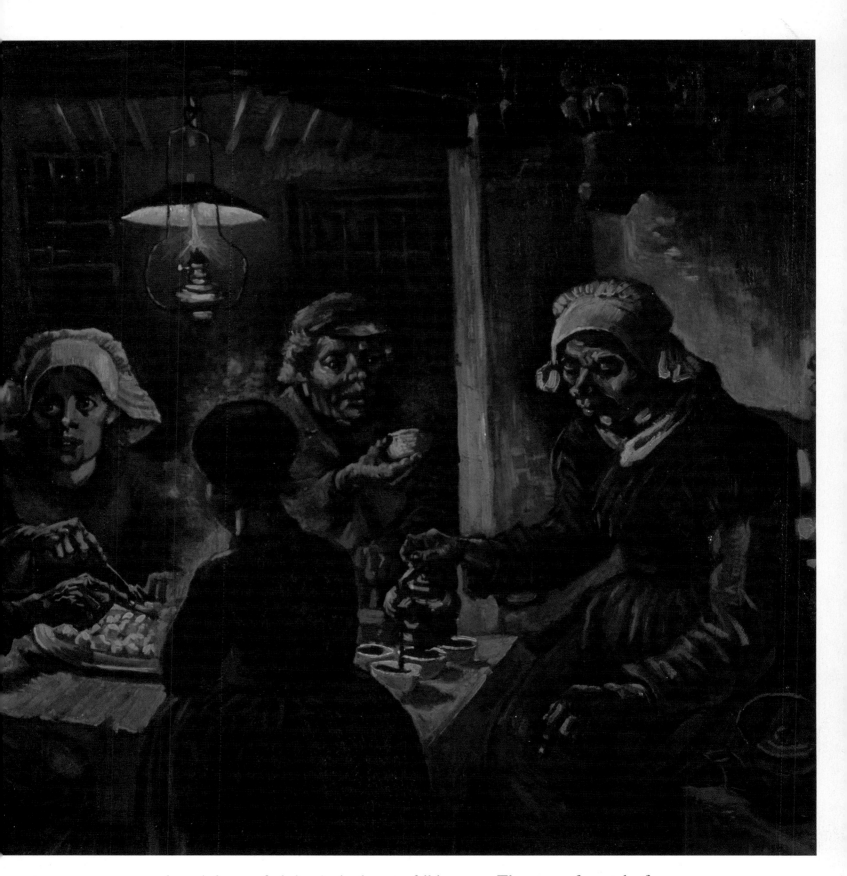

enlarged that we feel the sky is about to fall in on us. The sense of mental, of universal, dislocation is complete and overwhelming.

Since Van Gogh's time, art of this kind has acquired a name: it is described as 'expressionistic'. The expressionist is almost by definition an individualist, pre-occupied with his subjective reactions; but although expressionism has never been a distinctive movement with a set programme, it has certainly been a persistent tendency in modern art. It has appeared in a variety of guises which have in common only the artist's practice of modifying reality in the interests of emotional truth – in order, as Van Gogh himself stated, that the picture might be 'truer than the literal truth'. Besides being himself a great painter, he was thus also a major influence on modern art, since 20th-century expressionism effectively begins with the breaking down of barriers that Van Gogh accomplished.

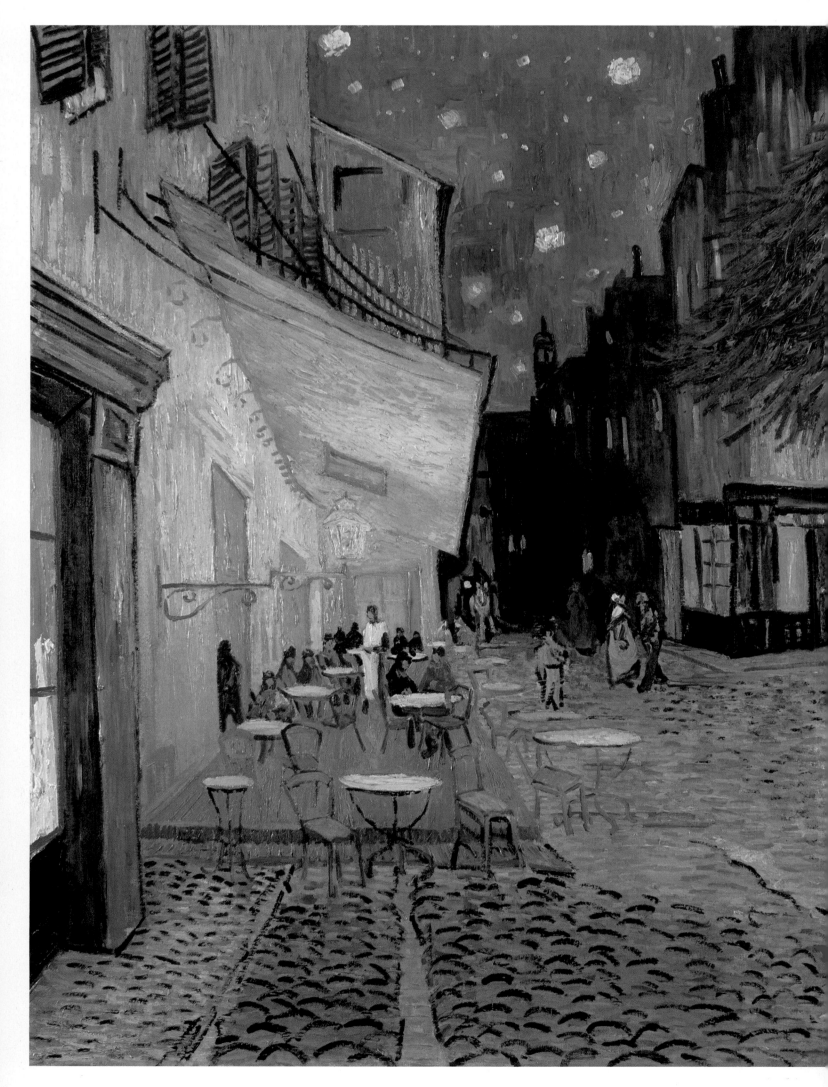

Our understanding of art in general also owes much to his soul-searching and theorizing. He left behind a fascinating record of this in the hundreds of letters he wrote, most notably to his brother, Theo. Perhaps no other artist has discussed his methods and intentions so fully and articulately. The letters reveal, like nothing else, the years of laborious copying and sketching and experimenting that go into making a master – that is to say, an artist capable of translating the inspiration 'of the moment' into a durable work of art. For Van Gogh, painting was a moral, even a religious, activity; the fervour and the conviction of the evangelist simply found a new medium when he turned to art, which became for him a way of life rather than a craft or a profession, or even a vocation. He found it hard to understand how anyone could spend his time on anything less 'serious', and for a time he even tried to persuade his brother to abandon art dealing and become a painter – despite the fact that Theo's earnings in business had been Vincent's sole support for years!

For better or for worse, this elevation of art into a religion is characteristically modern; and part of Van Gogh's fascination is that he was thoroughly modern in this and so many other ways. His dedication to art never wavered. In his last, unfinished letter to Theo he said this of his work: 'I am risking my life for it and my reason has half foundered because of it – that's all right.'

Left: *The Café Terrace on the Place du Forum, Arles, at Night.* September 1888. Rijksmuseum Kröller-Müller, Otterlo.

A page from one of Vincent's letters to his brother Theo. It was written from Drenthe, probably on 14 November 1883.

The Early Years

Below: *Portrait of Van Gogh's Father*. 1881.
A pencil and washed Chinese ink study of
Pastor Van Gogh, who seems to have been
an uninspiring but well-intentioned man,
perhaps more sinned against than sinning
in his relations with Vincent. Private
collection.

Bottom: Pencil study of a bridge. 11
January 1862. Executed when Van Gogh
was eighteen. Rijksmuseum Kröller-
Müller, Otterlo.

Vincent Willem van Gogh was born on 30 March 1853 at Groot Zundert, a
village in southern Holland. He was the eldest son of Theodorus van Gogh, a
minister of the Dutch Reformed Church, and his wife, Anna Cornelia Carbentus.
Exactly a year before Vincent's birth, Anna had been delivered of a boy, also
christened Vincent Willem, who had died within a few weeks; writers with a
taste for psychoanalysis have speculated that the painter may have suffered from
a lifelong guilt at having usurped the dead child's place; but the evidence to
support such a view is, to say the least, thin. In time Vincent was presented with
two more brothers and three sisters, although in adult life his only real intimate
among them was Theodorus ('Theo'), who was born in May 1857.

Some members of the Van Gogh family had made their mark in the world: no
less than three of Vincent's uncles had become art dealers, while a fourth had a
distinguished career in the navy and retired as a rear admiral, at that time the
highest rank in the service. By contrast, Vincent's father spent his whole life
as an obscure minister, periodically being moved on by his superiors from one
little Dutch village to the next; he seems to have been conscientious enough in
the performance of his pastoral duties, but to have had few gifts and little power
to inspire others. Vincent therefore grew up in an atmosphere that was not only
conventional in the 19th-century fashion but also narrowly provincial.

In adult life, the mental incompatibility between Van Gogh and his parents
gave rise to serious conflicts. But although he is said to have been temperamental
even as a boy, Vincent's childhood was an apparently uneventful one. He was
taught at home by a governess until he was twelve, and was then sent to a board-
ing school at Zevenbergen, about twenty-four kilometres from Groot Zundert.
He was fond of drawing from an early age; surviving examples of his work are
highly competent, but not exceptionally so for the period. Drawing was widely
encouraged as an elegant accomplishment, with a premium being placed on
accuracy and technique, and many 19th-century children's productions look
precocious to modern eyes.

At sixteen, when he was sent out into the world to earn his own living, Vincent
van Gogh was marked down as one destined to sell rather than to create works
of art. One of his art-dealing uncles – also a Vincent van Gogh – had become a
partner in the firm of Goupil & Co., which was successfully established at The
Hague, Brussels, London, Paris and Berlin. Thanks to his 'Uncle Cent', the
younger Vincent was taken on by Goupil's at The Hague. This, like other
branches of the firm, concentrated on selling high-quality reproductions of
paintings; only the Paris headquarters dealt seriously in originals. None the
less, over the next few years Van Gogh acquired a valuable knowledge of art
both at his workplace and in the public galleries of the cities where he was
employed.

During the four years he spent at The Hague, Van Gogh seems to have been a model employee. As a result, in May 1873 he was promoted by being sent to work in the London branch of Goupil's, where he sported a top hat, learned excellent English, acquired a taste for the writings of Dickens and George Eliot, and haunted the city's museums and galleries. But he also fell in love with his landlady's daughter; characteristically, he nursed his passion for a long time without telling the girl how he felt – only to find, when he at last did so, that she was engaged to another man and quite indifferent to him.

This rebuff seems to have brought on the first great change in Van Gogh's outlook. He withdrew gloomily into himself, becoming increasingly preoccupied with religious ideas. His parents were so worried that they arranged for him to be transferred to Paris in October 1874, presumably in the belief that life in the famous city of pleasure might raise spirits that had been depressed by London's murky streets. In the event, Van Gogh seems to have resented being interfered with, and to have sulked until his return to London in December 1874. Curiously enough, his stay in Paris occurred only a few months after the first, scandalous Impressionist exhibition held in April, when the colourful, rapidly executed works of the Impressionist painters were denounced by many critics as no more than hasty daubs. Van Gogh's art was to be deeply influenced by Impressionism, but at this time and for some years to come he seems to have remained unaware that there had been such a revolution in the art of painting.

London failed to 'cure' him, and in May 1875 he was transferred to a permanent position with Goupil's of Paris. But although he lodged in Montmartre – already the part of Paris most strongly associated with art and the glamour of night-life – Van Gogh spent his free time away from temptations, engaged in protracted Bible readings with a like-minded youth. His increasingly erratic behaviour at work was crowned by an unlicensed trip back to Holland which he took at the height of the busy Christmas season. After this, his days at Goupil's were clearly numbered, and it can only have been his uncle's influence that

Pencil study of a dog, after a lithograph by Victor Adam. 28 December 1862. Signed and dated. Rijksmuseum Kröller-Müller, Otterlo.

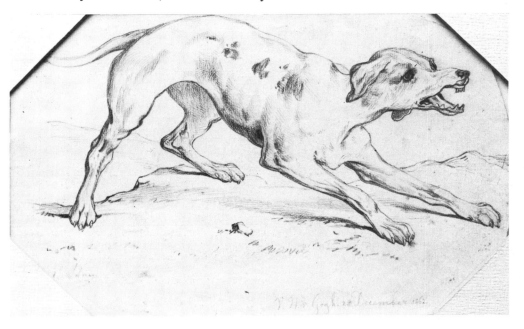

prevented his instant dismissal. Instead, he was allowed to carry on for a few months before leaving the firm on 1 April 1876.

This ended what may be called the prudent phase of Van Gogh's life. Returning to England, he took a job as an unpaid teacher, receiving nothing more than board and lodging, at a boys' school in Ramsgate, on the Kent coast. The school was a small, seedy, rundown place, of a kind that was all too common in 19th-century England; Vincent soon left it for a more religiously-oriented post in the London suburb of Isleworth where, on occasion, he was even permitted to preach a sermon. Congenial though this may have been, it scarcely offered a living, let alone prospects of advancement; and on Vincent's return home for the Christmas holidays a family council decided that it was pointless for him to go back to England.

Uncle Cent stepped in to help once more, and Vincent was packed off to work in a bookshop in nearby Dordrecht. His family may have supposed that the job would suit such a passionate reader. If so, they were soon to be proved wrong,

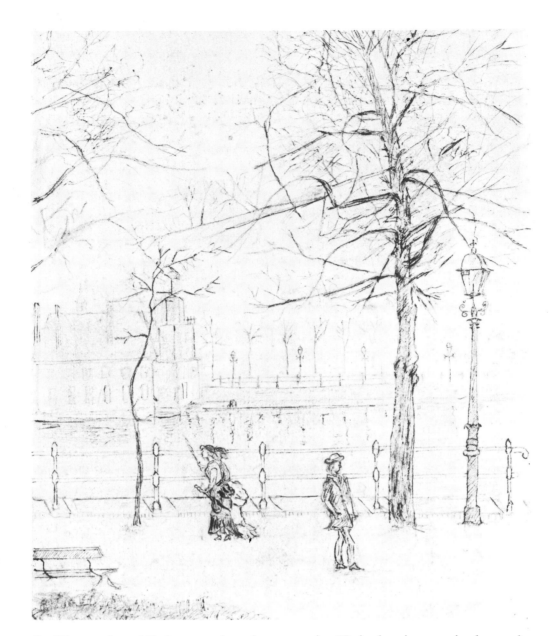

The Lange Vijverberg in the Hague. 1869–73. Pen and pencil drawing. Vincent van Gogh Foundation, Amsterdam.

for Vincent lasted little more than three months. He had no interest in the work; he wrote sermons while he was supposed to be keeping the books and, when he was called on to sell the fine engravings in which the shop also dealt, he would try to persuade customers that they should buy better and cheaper examples than the ones they asked for. Understandably, the proprietors did not view him – or, later, remember him – with affection. However, he made a powerful impression on a young teacher with whom he shared a room: this man, P.C. Görlitz, was able to write detailed recollections of Van Gogh some thirteen years later, after the painter's death. He remembered his friend's eccentric salesmanship, but more than anything else he was conscious of his goodness – a goodness amounting almost to saintliness. Vincent read the Bible constantly, never lost his temper (a characteristic that certainly didn't outlast his religious phase), rejoiced exceedingly when he persuaded Görlitz to come to church with him, lived the life of an ascetic, and on occasion spent his last few coins on rolls for a starving dog, thus depriving himself of tobacco – his sole vice – for his pipe.

Van Gogh's impulse towards the religious life was at last recognized by his family as too strong to resist. They arranged for him to live at The Hague with his uncle, the rear admiral, while he studied Greek and Latin to prepare himself for the university (a degree was a necessary qualification for a minister of the Dutch Reformed Church). Ironically, his instructor was a young Jewish scholar, Mendes da Costa, who realized that he was dealing with an unusual personality and exerted all his ingenuity to make Van Gogh's studies interesting to him. But it was no use, even though Vincent punished himself for his failures – belaboured his back with a heavy stick, spent nights on the floor of an outhouse instead of in his bed, and walked round Amsterdam without an overcoat on bitter winter days. Van Gogh did his best – or thought he did – but apparently he could not master the intricacies of Greek verbs. His failure is something of a mystery,

since he was not only intelligent but also had a specific gift for languages; he had acquired fluent English and French a few years earlier with a far less powerful motivation than he possessed in Amsterdam. A clue to the mystery may be found in the complaints he sometimes made to Da Costa: these 'horrors' (Greek and Latin) had, he said, absolutely nothing to do with preaching the Gospel and reconciling miserable men to their earthly lot. It is easy to sympathize with Van Gogh over this, but hard to avoid the suspicion that on some level of his being he had made up his mind to fail because he disapproved of what he was being required to do. On this and similar occasions we find him adamantly refusing to accept the way of the world, even when doing so defeated his own dearest ambitions. And not all of these refusals can be put down to the operations of an inflexible integrity; often they arose from an inward-looking wilfulness – an incapacity for taking account of other people's feelings and opinions – that smacked of self-destructiveness.

Subsequent events confirmed his inability to make concessions in any cause. Having given up his studies with Da Costa, Van Gogh succeeded in discovering a way into the religious life that dispensed with Greek and Latin. In August 1878 he enrolled for a three-month course at a college in Brussels that had been set up to train lay evangelists; from Brussels they would go on to evangelize the Borinage, the coal-mining area around Mons in southern Belgium. But although Van Gogh was one of the most gifted of the students, his eccentricity and opiniona-

Vicarage and Church at Etten. April 1876. Pencil drawing done in the village of which Van Gogh's father was pastor; Vincent had just been dismissed from his position with the art dealers Goupil & Co. in Paris, and was about to leave for England. Vincent van Gogh Foundation, Amsterdam.

tiveness made a bad impression, and – at least by the standards of the college – he turned out to be a poor public speaker. At the end of the course he was not among those selected by the evangelical committee to go on to the Borinage.

He went all the same, with moral and financial support from his parents; although pessimistic about twenty-five-year-old Vincent's ability or willingness to modify his eccentricities, they encouraged him to persist in his religious vocation. The plan was that he would work independently among the miners for a few weeks, in the hope that his show of initiative would persuade the committee to reconsider its decision when it met again in January 1879. Meanwhile, Van Gogh tended the sick, held Bible readings, and gave lessons to the children of the house in which he lodged. The plan worked (with some lobbying on the part of Vincent's father), and Van Gogh was formally taken on for a trial period of six months.

The Borinage made a deep impression on Van Gogh. His painter's eye noted the pictorial effect made by coal-blackened miners in a snowscape; at the same time, his compassion and social conscience were touched by the appalling conditions of their existence. Van Gogh's letters bring to life the dirty, ravaged landscape, the workers' humble little huts, and the undersized, pallid, emaciated miners and their worn-out wives, old before their time. After going down a mine he left a particularly vivid description of the cramped cells in which the men worked on the coal-face, while small boys and girls did most of the loading and old horses pulled along the waggons of coal. Even by the lax standards of the time, the mines of the Borinage were scandalously unsafe, and there were frequent disasters caused by firedamp, flooding, bad air and cave-ins. In fact, Van Gogh's account of the place is similar in essentials to that given only seven years later by one of his heroes, the French novelist Emile Zola, in his masterpiece, *Germinal*.

Square at Ramsgate.
May 1876. Pen and
pencil study, done
in the Kentish
seaside town where
Van Gogh worked
briefly as a teacher;
he remained in
England from April
to Christmas 1876.
Rijksmuseum
Kröller-Müller,
Otterlo.

Whether or not he was successful as an evangelist, Van Gogh seems to have been accepted by most of the local miners and their womenfolk. He himself identified passionately with them – too passionately for the liking of the evangelical committee that had appointed him. He gave away his respectable preacher's suits and dressed like a workman; he left his comfortable lodgings for a hut with a makeshift bed; and he denied himself the luxury of soap so often that – according to one otherwise quite sympathetic account – he usually looked dirtier than the miners among whom he lived. As ever, he ran to extremes – although the extremes might be splendid on occasion, as when he tore up his linen to serve as bandages for the injured after a pithead accident. Van Gogh's notions of Christian humility and self-denial might have been admired in the early centuries of the Church; in sober-suited 19th-century Europe they were utterly at variance with what was expected of a man of God. He must have known as much, but again he chose to behave as though the outside world could not touch him if he ignored its existence. Inevitably the evangelical committee, though appreciative of Van Gogh's good qualities, decided not to renew his contract.

Apart from brief visits to his parents, Van Gogh spent the winter of 1879/80 in the Borinage, where he underwent a spiritual crisis. He was now unemployed, desperately poor and lacking in any sense of direction, yet he longed as passionately as ever to be of some use in the world – above all, to serve. At the same time, frustrated by circumstances that were largely of his own making, and perhaps feeling guilty and humiliated at disappointing so many hopes, he cut himself off from his family for a long time, and afterwards was inclined to rail at them for real or imagined attempts to 'interfere' with him – a form of grievance that was to recur in his letters for years to come, perhaps foreshadowing the persecution mania that afflicted him towards the end of his life.

He even broke off relations with Theo for several months, although it was already clear that his younger brother was the only person in the world who really understood and believed in him. Following in Vincent's footsteps, Theo had left school and joined Goupil's when he was sixteen, working first at Brussels and later on in Paris. The brothers wrote to each other regularly, and Vincent's letters to Theo are our chief record of the artist's life – a satisfyingly rich and detailed account of his physical and mental struggles, his thoughts about art and society, his extensive reading, his technical researches and his achieved works. The letters also display some mildly paranoid attitudes that go a long

way towards explaining the difficulty Van Gogh experienced in keeping friends; his touchy reaction to the slightest hint of criticism was the obverse of the humility he cultivated in the presence of unassuming people. To the very end he remained capable of breaking out furiously against Theo, despite the fact that from this time onwards Theo was virtually his sole financial support; Vincent's parents remained kind, helped when they could, and were prepared to let him live with them if he would only dress and behave reasonably, but they had evidently given up hope that he might amount to anything. Towards the end of his stay in the Borinage, the tone of Vincent's letters to his brother changed in a significant fashion; the relationship between the two men reversed, and Vincent wrote as well as behaved as though he were the younger brother. Soon Theo began to make him a regular allowance from his salary at Goupil's, as well as responding more often than not to Vincent's all-too-frequent and pointed reports that he had run short of funds for some reason or other.

Some of the remarks made above may seem rather unsympathetic towards Van Gogh, who was after all a genius, fiercely sincere and capable of utter dedication when once he had found his destiny. However, his negative qualities explain the reasons for his often painful isolation, and highlight Theo's character – Vincent himself insisted that Theo ought to be regarded as part-author of his works. His parents and his evangelical superiors were admittedly dull and conventional people, but nevertheless it is doubtful whether any family or any institutional structure could have tolerated such an impossible genius for the duration. That Theo never wavered must be accounted the saving miracle of Vincent's existence.

Van Gogh's dark months in the Borinage proved to be a turning point. By the summer of 1880 he had at last discovered his true vocation as an artist. Disillusioned with organized religion, he embraced the cause of art with the single-minded fervour of an evangelist; but although he achieved even less official success in practising this new religion than he had in the old, from now on there were to be no more changes of direction. His long apprenticeship had begun.

Miners. August 1880. Pencil study, lightly coloured; it was done shortly after Van Gogh discovered his artistic vocation. Rijksmuseum Kröller-Müller, Otterlo.

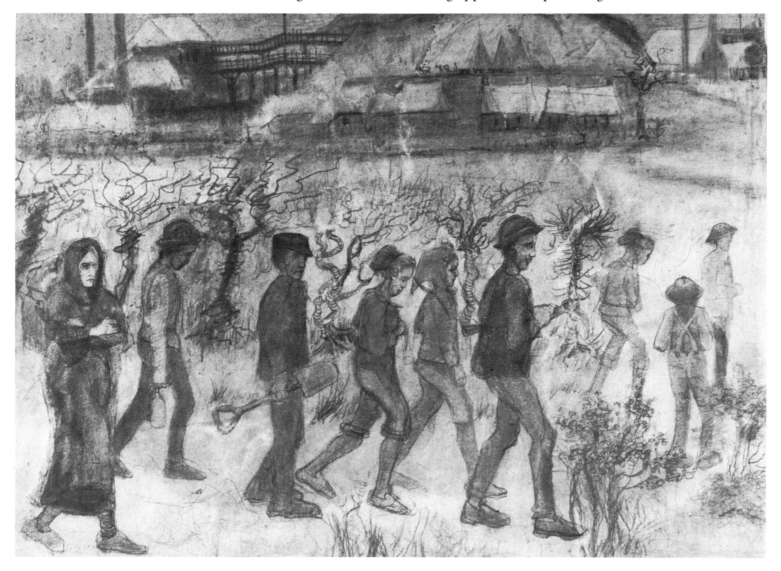

The Long Struggle

Van Gogh's letters make clear the tremendous sense of liberation he felt on taking up drawing again. His passion for art was certainly nothing new or sudden; we catch glimpses of him sketching in the various doldrums of his earlier career – on holiday, for example, after his disappointment in London – and almost from the beginning his letters were full of references to paintings and painters. Art, literature and religion were, in his mind, aspects of the same central mystery, and he mentions Rembrandt, Shakespeare and the Gospels in the same sentence without the slightest sense of incongruity. He himself had made a pilgrimage of sorts during the winter of 1879/80 before irrevocably fixing on art as his vocation. He had tramped for a week, sleeping rough, to reach Courrières, intending to visit the painter Jules Breton, whom he had briefly met during his time at Goupil's. Quite what sort of illumination he hoped to receive from Breton will never be known, since Van Gogh was so intimidated by the artist's new brick house, with its 'Methodist regularity', that he dared not knock on the door and introduce himself. After wandering disconsolately round the village in the hope of seeing some of Breton's work, he left and tramped all the way back to the Borinage again.

By July 1880, Van Gogh was describing himself as 'homesick for the land of pictures', and soon afterwards the decision was taken. He then settled down in

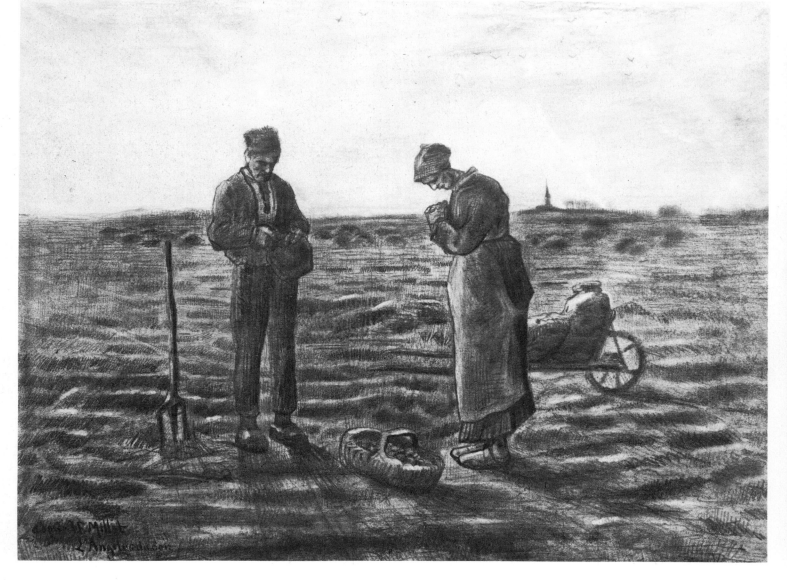

The Angelus. October 1880. A copy of Jean-François Millet's famous painting, done by Van Gogh in pencil, red chalk and wash. Millet's works, which now seem a little sentimental, deeply influenced Van Gogh, who shared Millet's interest in the labouring classes, an interest relatively rare in the escapist atmosphere of 19th-century art. Rijksmuseum Kröller-Müller, Otterlo.

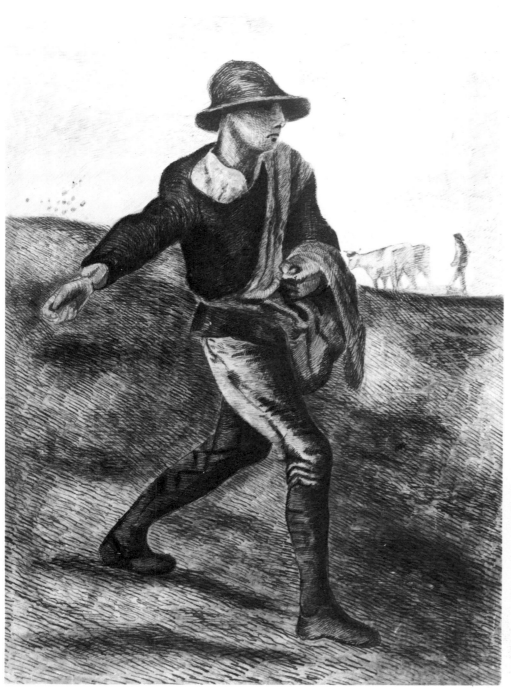

Left: *The Sower*. August/September 1880. Van Gogh's version of Millet's work, done in pen and wash heightened with green and white. Vincent van Gogh Foundation, Amsterdam.

Above: Jean-François Millet. *The Sower*, etching by Paul le Rat from Millet's series 'Les Travaux des Champs'. Bibliothèque Nationale, Paris.

'a rage of work', studying and drawing with a will. The friendly manager of Goupil's branch at The Hague supplied him with textbooks on anatomy and perspective, which Vincent found rather dry but steeled himself to master – a significantly different attitude from his earlier refusal to tackle the necessary grind of Greek and Latin. Now he dutifully copied prints of works by such admired masters as Millet, both the prints and the drawing materials being supplied by Theo, who was full of encouragement for his brother's new venture. At this point Vincent's ambition was seemingly modest and realistic: he hoped to become an illustrator of books and magazines rather than a painter, which meant that he could hope to become proficient and sell work in the relatively near future. Illustrating also appealed to him because of its journalistic immediacy; unlike so many 19th-century painters, revelling in exoticism and historical set-pieces, the illustrator portrayed contemporary types and touched on real social problems. For Van Gogh had lost nothing of his compassionate involvement with the poor and downtrodden, and he intended that his art should be of some service to them by arousing pity and indignation. Working outdoors, he sketched the peasant women pulling up potatoes in the fields, and he dreamed of winning a new understanding for such despised groups as the miners and weavers, who were then widely regarded as the dregs of the working population. Among contemporary artists, Van Gogh particularly admired English illustrators for their social awareness; indeed he easily persuaded himself that mediocre work was excellent if he approved of its subject-matter,

and perhaps the majority of the artists he mentions in his letters have now been utterly forgotten.

His artistic puritanism was such that for years he even entertained doubts about the value of landscape paintings and drawings done for their own sake; he held that the supreme artist, like Rembrandt, occupied himself almost exclusively with man, and made the quality of his soul felt throughout his work. Only gradually did he realize that a landscape could be so rendered that it mirrored the artist's soul.

For several months, Van Gogh's joy in the discovery of his art enabled him to ignore the discomfort in which he lived. For him, home and studio were a miner's shack where he shared a bedroom with the children of the family. This was not so bad in summer, when he could work out of doors, but as the nights drew in the situation became hard to bear; besides, after two years in the Borinage he longed for city life and stimulating companionship. In October 1880 he moved to Brussels with the usual assistance from Theo, who also

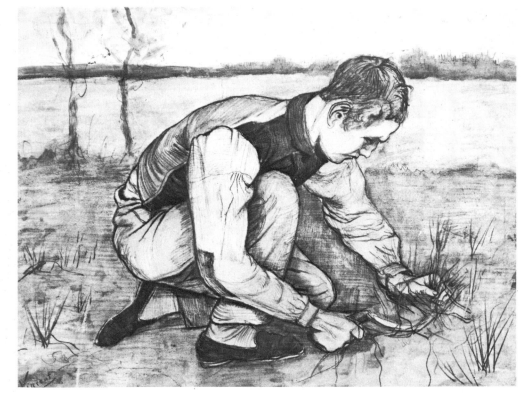

Boy with Sickle, Crouching. October 1881. Black chalk and watercolour. Rijksmuseum Kröller-Müller, Otterlo.

introduced him to Anton van Rappard, a fellow artist who was to remain Van Gogh's friend and correspondent for the next five years. But Brussels proved expensive and, after a hard winter in the city, Van Gogh began to long for the countryside; this alternation between city and countryside became the pattern of his restless existence until his death. He made his peace with his parents, even expressing his willingness to dress respectably, and in April 1881 went home.

Home was now the vicarage at Etten, a little village where Theodorus van Gogh had been the pastor since 1875. At first, after Vincent's return, everything went well. He became a familiar sight to the local people – eternally sketching, always in deadly earnest, eccentric but harmless. Life at Etten was quiet and monotonous, but there were enlivening visits from Theo and Van Rappard, with whom Van Gogh worked side by side in the fields. The summer passed without serious incident. Then a visitor came to stay with the Van Goghs – a cousin of Vincent's on the maternal side called Kee Vos.

Everything about Kee was designed to appeal to Van Gogh. She was older than he was – and he liked older women; and she was still grieving for the husband she had recently lost – a state of affairs that appealed to his compassion, always so powerful and so easily aroused. Having shed his evangelical faith and recovered from the austerities and deprivations he had undergone in the Borinage, he needed a woman; and now there was one to hand. The likelihood that Kee's grief might make her unresponsive to his advances seems never to have occurred to him, and he allowed himself to fall deeply in love with her. He made much of Kee's four-year-old son, perhaps hoping to touch her heart by this means; but when he finally poured out his feelings to her, she was astounded and alarmed.

When he pressed her too hard, she told him, 'No, never, never', but he was not to be convinced. Even when Kee hurried back to Amsterdam, Van Gogh besieged her with letters, all of which she returned unopened. Still clinging to his strange conviction that love could be generated by sheer will-power, he borrowed the rail fare to Amsterdam from Theo and turned up at Kee's parents' house, demanding to see her. She had slipped away before he had been allowed into the dining-room, and Van Gogh confronted her parents, who seem to have been embarrassed rather than angry at the intrusion. When they returned evasive answers to his demands, he held his hand out over the flame of a lamp and asked to be allowed to speak to her for just so long as he could keep it there – a wildly romantic gesture of the sort that, in real life, only appalls people. Kee's father hastily blew out the lamp, and after a long anticlimactic conversation the old couple escorted Van Gogh through the streets until they had found him lodgings for the night. He lingered on in Amsterdam for two more days, but he was never permitted to meet Kee again.

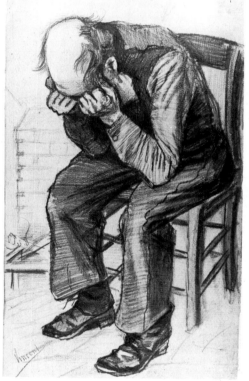

Old Man in Sorrow. November 1882. Black chalk and pencil. Vincent van Gogh Foundation, Amsterdam.

Van Gogh's behaviour created a family scandal and ruined his relations with his parents. When they talked of the danger that the affair might break family ties, Vincent was outraged and refused to speak to his parents for days – punishing them, as he made perfectly clear, by demonstrating what a real breaking of ties would be like. When, as a result, his father damned him and told him to get out, Vincent was actually shocked at such behaviour on the part of a minister. He provoked a final crisis on Christmas Day, 1881 by refusing to go to church, explaining that he had only conformed up to that point out of respect for his parents, and that he regarded organized Christianity as an abomination. After the row that followed, Vincent left home for The Hague. As Theo pointed out, it was probably inevitable that Vincent should have been misunderstood by old-fashioned country folk such as his parents, but there was no possible excuse for the way he had treated them. For all his compassion – most actively exercised towards victims of social injustice – he could be clumsy, spiteful and morbidly irritable in any kind of personal relationship. This, more than any other circumstance, doomed him to the semi-isolation in which so much of his life was passed.

Van Gogh's choice of The Hague as his next place of residence was not accidental. After leaving Kee Vos's parents in Amsterdam, he had visited The Hague before returning home and had made two important contacts. One was his cousin Anton Mauve, a well-known painter who had received him with unexpected kindness and words of encouragement about his drawing. The other was a streetwalker nicknamed Sien, who had consoled him after his disappointment with Kee, and whom he now sought out. Although Sien already had an eleven-year-old daughter and was three months' pregnant, Van Gogh

Left: *The Church*. October 1882. Pencil, pen and watercolour. Rijksmuseum Kröller-Müller, Otterlo.

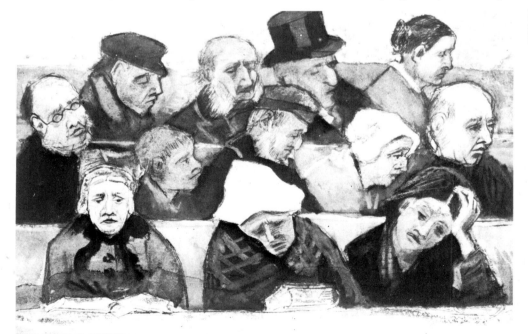

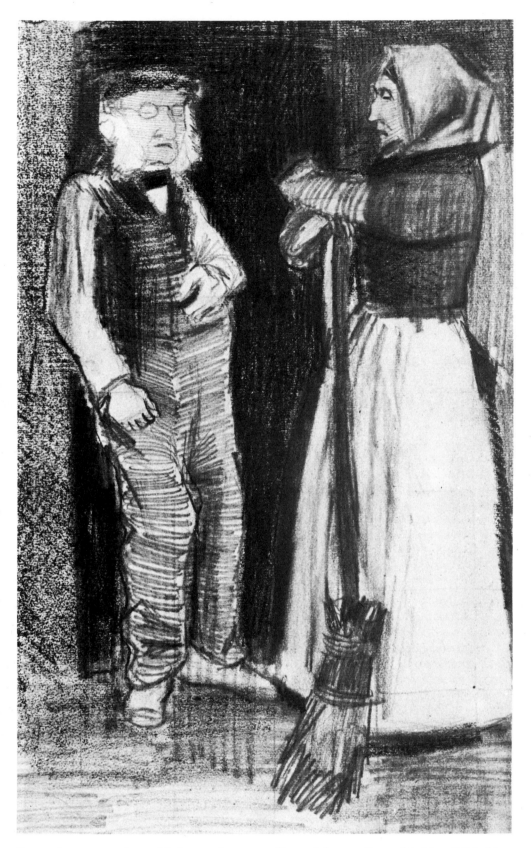

Man and Woman Talking. October 1882. Pencil and black chalk. Rijksmuseum Kröller-Müller, Otterlo.

formed a connection with her and eventually took her to live with him. Thinking of himself as an outcast, he felt a sympathy amounting almost to self-identification with streetwomen – who were, for that matter, romanticized by a great many 19th-century writers, including some who deeply influenced Van Gogh. Though pock-marked, bony and no longer young, the sickly, burdened Sien aroused his pity and evidently assuaged his desires; she even provided him with a ready-made family that promised to satisfy his craving for a home life such as other men of his age enjoyed.

Materially and artistically, his cousin Mauve helped Van Gogh a great deal during his first weeks in The Hague. He lent him money for rent and furniture, presented him with drawing materials, introduced him to other artists, and even gave him some lessons. However, Mauve began to cool towards his cousin when Van Gogh started to make too many demands on his time and patience. Vincent

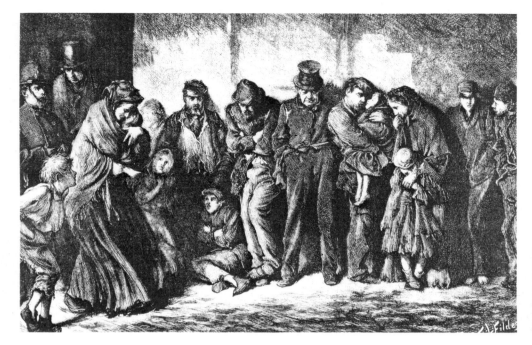

Left: Luke Fildes. *Houseless and Hungry*. Wood engraving, published in *The Graphic*, Volume I, 4 December 1869. An example of the social-commentary art that Van Gogh admired in the work of English illustrators. Victoria and Albert Museum, London.

was an exigent pupil, yet as opinionated as ever; when Mauve wanted him to work from plaster casts – a hallowed method of training an artist to acquire accuracy in drawing, though arguably at the expense of freedom and vigour – Van Gogh felt himself insulted, declared that he could only work from life, and smashed up the casts. Understandably, Mauve soon began to avoid him.

Mauve may also have been influenced by rumours about Van Gogh's private life. The Hague was a small city where, unlike Paris, respectability ruled even among artists. Van Gogh seems to have been regarded with suspicion almost from the first – perhaps for his plain speaking rather than any specific offence. At any rate, his uncle Cornelis – another of his art-dealing uncles – actually cross-questioned him about his morals before commissioning some views of The Hague from him – an instance of the suffocating closeness of family and social life that makes one rather more sympathetic towards Van Gogh's explosions of rage. The commission for a dozen drawings from 'Uncle Cor' was a welcome one, although Van Gogh was paid only a pittance for them; however, despite his poverty he declined to turn himself into a purveyor of picturesque views, and he soon managed to alienate both his uncle and Tersteeg, the manager of Goupil's Hague branch, who had also shown some inclination to help him.

Van Gogh's isolation intensified after he brought Sien and her child to live with him. In May 1882 he encountered Mauve on the sand dunes outside the city, and was snubbed: the older artist refused to come and see his work, telling him brutally, 'You have a vicious character.' Relations were broken off, to Van Gogh's regret. Vincent described the incident in a letter to his brother and at last told him about Sien – presumably because he was now likely to hear anyway. That he should have concealed the affair from Theo – his only intimate – is an indication of how shocking it was by the standards of the time; Van Gogh evidently feared that Theo might be outraged enough to cut off his allowance and leave him destitute. Feeling defensive, he went over to the attack with angry indignation, demanding to know whether there was anything reprehensible in raising the fallen, and announcing that he intended to marry Sien. Theo, now a Parisian man of the world, accepted the liaison calmly enough but strongly opposed the idea of marriage, which seems to have been quietly dropped. Perhaps Vincent already knew in his heart that Sien and he would never succeed in living together permanently.

Besides, there were other things to worry about. In June, various ailments that had been afflicting Van Gogh were diagnosed as the effects of gonorrhoea, which he had presumably contracted from Sien. He spent three weeks in hospital, and was never really well for months afterwards; no doubt his way of life had weakened his constitution and made recovery difficult. (Many of his later symptoms, including the loss of his teeth, suggest that he suffered from chronic undernourishment.) However, his illness did bring about a reconciliation with his parents. They sent him some money and a parcel of clothing and cigars, and his father visited him in hospital; in a later parcel they even included a hat and coat for Sien. In the meantime Sien had given birth to a boy, and the event

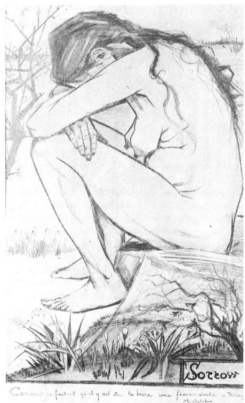

Sorrow. April 1882. Early black chalk version of this subject; the woman is 'Sien', the pregnant streetwalker whom Van Gogh had taken to live with him during his stay at The Hague. The Garman-Ryan Collection, Walsall Museum and Art Gallery.

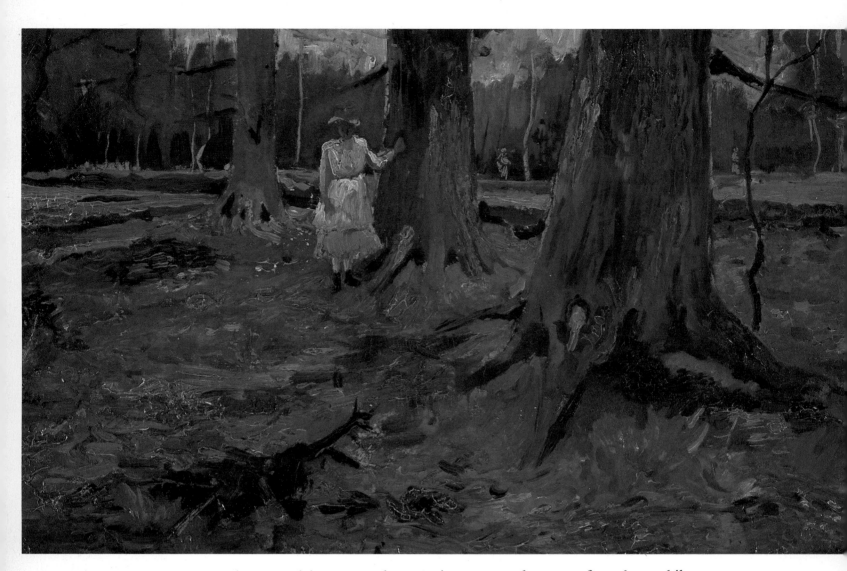

Girl in White in the Woods. August 1882. One of Van Gogh's earliest paintings, done at The Hague. Rijksmuseum Kröller-Müller, Otterlo.

seemed an auspicious one; the experience seemed to transform her, while Vincent found himself enchanted with the baby. They all moved into a larger studio, and for a time Van Gogh was able to believe that they had begun a new and better life.

Except when he was actually in hospital and forced to rest, Van Gogh continued to drive himself hard, drawing city views, third-class waiting-rooms, pensioners from the community almshouses, and similar subjects that mirrored his intense social awareness. He had succeeded in making some friends among the younger artists in The Hague, and they sometimes accompanied him on sketching trips; but he complained that they usually wanted to get out into the countryside and were unable to see anything but dirt and squalor in the life of the city. Van Gogh had already gone beyond this 'chocolate box' notion of beauty as mere picturesqueness, and of art as no more than a copy of nature in her most pleasing aspects. Feeling strongly and working hard, he had become capable of producing powerful images, although he found the acquisition of technical mastery a painfully slow process; much of his output was still awkward and rather static in feeling, more significant in intention than achievement.

One advantage of his connection with Sien was that she and her daughter provided Van Gogh with badly needed free models from which to work, and they were the subjects of some of his finest drawings from the period. One of these, *Sorrow* (Van Gogh wrote the title on the drawing, using the English word), is probably the best known of his early works. It shows a naked woman in an attitude of despair, squatting with her head buried in her arms. There is not the faintest suggestion of glamour about her: her hair is unkempt and her pose ungainly; her breasts are dangling dugs, and she is pregnant. Clearly the woman is Sien herself; the earliest version of the drawing (there are several) dates from April 1882 when she was heavily pregnant, and Van Gogh has pointed the message by adding to it a quotation from the French historian, Jules Michelet: 'How does it come about that there should be on earth a woman alone and abandoned?' To many tastes, *Sorrow* is overemphatic, representing Van Gogh at his most programmatic, all too determined to touch people, to express 'some-

thing straight from my own heart'. Still, if *Sorrow* is not a great work of art, it did demonstrate Van Gogh's originality, since his treatment boldly ignored the powerful European tradition of the nude as a necessarily sensual, or at least glamorous, element in almost any kind of composition.

Shortly afterwards, in August 1882, Van Gogh at last began to paint. It is typical of the man that he wrote to Theo explaining why he had not yet taken up painting – first he had to master drawing, and in any case paints were too expensive – only a few days before he gave in to the impulse. Then he admitted to Theo how often he had suppressed a longing for this 'broader horizon'; and within days he was telling his brother that 'while painting, I feel a power of colour in me that I did not possess before, things of broadness and strength'. His sense of liberation was evidently enormous – and to us, hardly unexpected: what seems so astonishing is that a man who was to become one of the world's great colourists should have had the strength of mind to restrict himself to drawing for two whole years. All the same, materials *were* expensive, and Van Gogh therefore became more dependent than ever on his brother; his letters to Theo at about this time make painful reading, mixing in broad hints with neutral-sounding but transparently slanted arguments that were designed to make Theo 'decide' that Vincent should go on with painting. Even with Theo's support, Vincent was not yet certain of his destiny, and part of the time, at least, continued to think in terms of eventual success as an illustrator.

Among Van Gogh's earliest paintings are such works as *Girl in White in the Woods* and *The Beach at Scheveningen*, which already include some features that were to become characteristic of his art. They look rather dark to our eyes, but Van Gogh's contemporaries might well have been more struck by the spots of bright colour that occur here and there; most Dutch painters still worked in an extremely sober style, as yet untouched by the French experiments with pure colour that had been going on for a decade or more. Even more remarkable was the freedom with which Van Gogh handled paint; from the first, he worked with such urgency that he squeezed paint directly from the tube onto the canvas, creating a heavy *impasto* that was in the strongest possible contrast to the smooth, 'invisible' finish favoured by most orthodox artists. Furthermore, having regu-

The Beach at Scheveningen. 1882. Despite its early date, a picture notable for the freedom with which Van Gogh has handled the paint. Stedelijk Museum, Amsterdam.

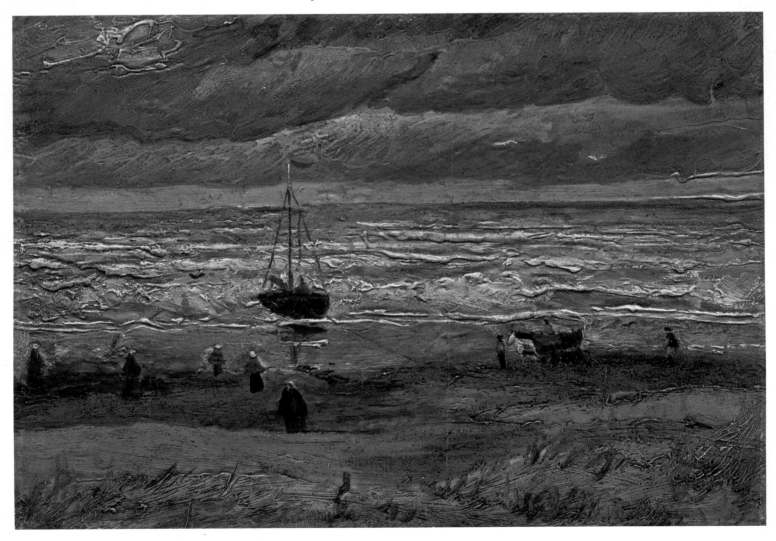

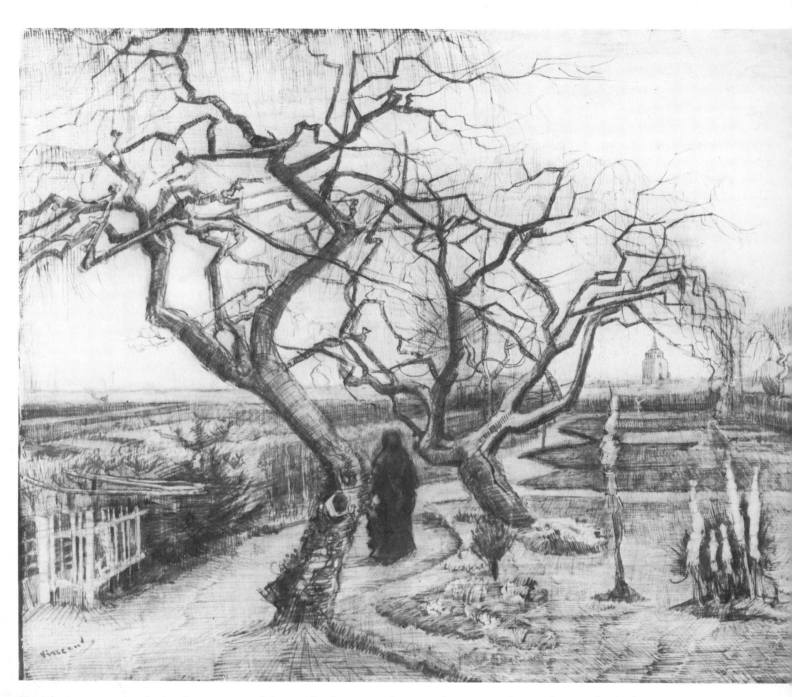

The Vicarage Garden at Nuenen in Winter. March 1884. A masterly, sinister, mysterious work; the lonely woman and gnarled, menacing trees are emotionally expressive to a degree not achieved before by Van Gogh. Rijksmuseum Vincent van Gogh, Amsterdam.

larly drawn out of doors, he kept up the practice as a painter; he particularly enjoyed the meeting of sand, sea and sky on the coast at Scheveningen, where he worked until the onset of winter, sometimes in weather so gusty that grains of sand lodged in the paint and were incorporated in the picture. In all of these respects Van Gogh was already a subversive – at least in Dutch terms – when he had hardly begun to master his craft.

His personal life during this period was gradually deteriorating. His unconventional relationship with Sien, abetted by his own touchiness, limited the fruitful contacts he could make with fellow-artists; at the same time, the relationship itself was bringing in less and less in the way of returns for the sacrifices Van Gogh had made. Sien was foul-mouthed and slovenly, and she managed to combine extreme lethargy with a general discontent. She had no interest in Vincent's work, and her mother was a trouble-maker who, so Van Gogh believed, would have preferred Sien to have the security of a brothel job than a precarious existence with an eccentric and impoverished artist. Eventually Van Gogh faced the fact that he and Sien were impossibly ill-matched. Matters had to be brought to a head because he was growing tired of the city and knew that Sien would never be able to tolerate the monotony of life in the country. Yet he felt sorry for her, and was also reluctant to admit that he had failed in his chosen role as her saviour. At last he nerved himself to leave her, but he suffered for it; even after their parting in September 1883, when Van Gogh left The Hague, the mere sight of a poor woman carrying a child was enough to bring him to the verge of tears. The sense of guilt remained with him for months.

His new home was in the north-eastern province of Drenthe, whose forbidding heaths and moorland had already attracted Dutch landscape artists. In his impulsive enthusiasm Van Gogh dreamed of setting up an artists' colony there. (This was very much the impossible dream of an idealistic, difficult, solitary man who found it hard enough to get on with others in the less hostile environment of the city; Van Gogh was to dream it again, all the same, at Arles.) At first sight, Drenthe had 'old world charm': the 19th century, with its factories, railways and machines, seemed far away in this rural backwater. But so did light and hope. Drenthe was a hostile place in which – to judge from the work Van Gogh produced there – men, women and the earth itself were crushed beneath huge, lowering skies; here, Van Gogh's peasants and peat-gatherers seem more the victims of the landscape than of the social system. There were practical difficulties, too: the local people were reluctant to work as models, even for pay, and there was nowhere to buy artists' materials. There was no sign of a fellow-artist anywhere. As the weather grew worse and the long winter nights deadened the land, Van Gogh fell into a terrible depression, dwelling on the succession of failures which was all his life seemed to amount to. By December 1883, less than three months after his arrival, he was glad to leave Drenthe and once more take refuge with his parents.

Pastor Van Gogh had been moved yet again, to the little village of Nuenen. Despite previous misunderstandings, Vincent was welcomed at the vicarage, where his parents arranged for the repair of an old shed used for laundry, which now served as his studio. He remained in the village for almost two years, from December 1883 to November 1885, despite a number of emotional crises. Some of these involved Theo, with whom Vincent had several quarrels-by-correspondence. During his stay at Drenthe he had decided that Theo too should become an artist, and the notion soon became one of his fixed ideas. Perhaps Vincent hoped for relief from his own isolation in the form of a brotherly collaborator; perhaps he wanted to take up the role of elder brother again, leading and teaching his junior. There is no knowing quite how he thought the

Two drawings from Van Gogh's Nuenen period. Below left: *Peasant Woman Stooping*. August 1885. Below: *Peasant Reaping*. Summer 1885. Both Rijksmuseum Kröller-Müller, Otterlo.

two of them could survive without a source of income. At any rate, he persecuted Theo with this plan for a long time, arguing that the painter's way of life, as 'a man among men', was superior to that of the businessman. This involved something more than the contempt for the 'bourgeois' that was so commonly expressed by 19th-century artists; Van Gogh's reading had made him an ardent radical, and although he never took up very definite political positions, he was clearly in sympathy with workers, democrats and other rebels against 19th-century systems of government, business and religious authority. Theo's refusal to throw up his job was, in Vincent's eyes, equivalent to siding with the system – which made his condition of dependence all the more humiliating. But a few months later he was denouncing Theo for not trying to sell his work, and raging against his brother's 'financial power' . . .

Van Gogh's relations with his parents were similarly uneasy. His father was dismayed at having a thirty-year-old son who was still not settled in a respectable career; Vincent in turn blamed the pastor for corrupting Theo with such ideas so that his younger son had given himself into commercial slavery. Good relations were restored in time, and Vincent seems to have learned, belatedly, how to handle his father tactfully. There was another upheaval to come, however, over Vincent's relationship with one of the next-door neighbours, a spinster in her forties named Margot Begemann. In this instance it seems to have been the woman who pursued him with unwanted ardour, swallowing poison (pumped out of her in hospital) when she failed to win him. Van Gogh's behaviour towards her had certainly been ambiguous, and he afterwards had to endure not only family criticism but a certain amount of local unpopularity.

The Weaver. February 1884. Pencil, pen and ink drawing of a subject to which Van Gogh returned several times: the worker as prisoner of the machine. Vincent van Gogh Foundation, Amsterdam.

Right: *Head of a Peasant Woman.* 1885. Evidently closely related to *The Potato Eaters.* National Gallery of Scotland, Edinburgh.

Meanwhile, he continued to work with his accustomed energy. At Nuenen his drawing became much more powerful and assured. He made a host of portrait, still-life and landscape studies, including meticulous but evocative records of the vicarage and its surroundings. One drawing is particularly striking, since it anticipates his later expressive manner; it shows the garden at Nuenen as a deeply mysterious place, with the dark figure of a woman framed by gnarled, skeletal trees whose branches seem to reach out menacingly in all directions.

For the most part, however, Van Gogh was still preoccupied with toil and toilers, which he regarded as a distinctively 19th-century contribution to art; the old masters, he observed, had painted working people from time to time, but never people at work. His hero of heroes was the French painter, Jean-François Millet (1814–75), whose *The Sower, The Winnower, The Angelus* and similar works showed much sympathy for peasant life and a certain insight into it. But Van Gogh had already surpassed Millet in certain important respects. Where Millet sentimentalized, Van Gogh showed both the strain involved in working and its physical effects in coarsened features and calloused hands. Along with splendid drawings of planting, gleaning, weeding, woodcutting, etc., he created a group of paintings, watercolours and drawings devoted to the weavers of the area, men seemingly trapped in their looms and mesmerized by their operation.

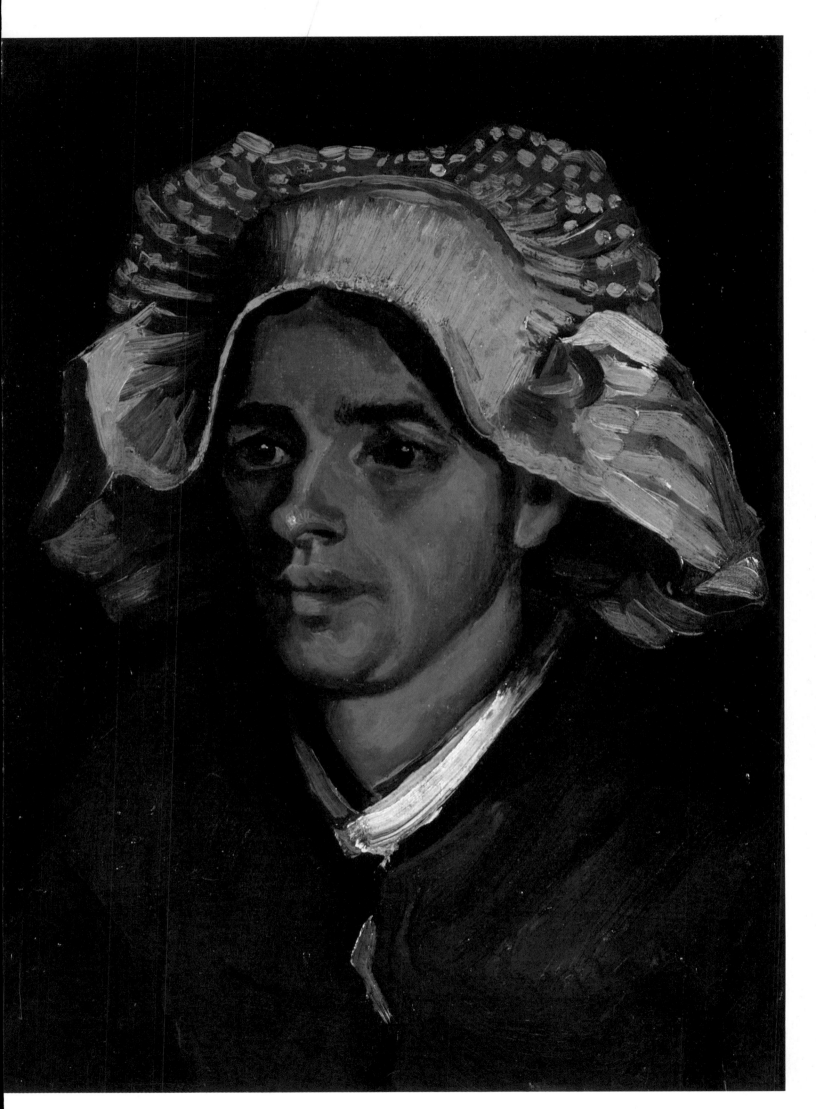

In March 1885 Pastor Van Gogh suddenly collapsed and died. Vincent's letters make remarkably little of the event – and much of a new canvas he was planning. *The Potato Eaters*, painted in May 1885, undoubtedly represents a climax of sorts in his work, carefully prepared for in preliminary studies and duplicated in a lithographic print. It is realistic to the point of being almost grotesque; Van Gogh remarked that such a picture should smell of bacon, smoke and steaming potatoes. The interior, inadequately lamp-lit, is dim and dingy. The family are brutalized in appearance, like peasant characters straight out of Zola's *Earth* – the book on which, by an extraordinary coincidence, the French novelist was about to begin work. As a result, the impression made on the spectator is more equivocal than Van Gogh intended; for him, the dimly lit interior, the coarse clothing and knotty hands were meant to reveal the hard manual labour that had gone into providing the meal, and to put 'civilized' people to shame. Some commentators have even gone beyond Van Gogh himself and interpreted the meal as a sacrament, a kind of Mass of Labour. The picture has always had both admirers and detractors; what is not in doubt is that, whether artistically successful or otherwise, it was the work of a most unusual personality who might ultimately prove to be a genius.

Shortly after his father's death, Van Gogh quarrelled with his sister and left the vicarage; but he remained in Nuenen until November 1885. The fullest account of him at this period was left by Anton Kerssemakers, then a fledgling painter in the area whom Van Gogh took considerable pleasure in guiding; it was a new experience for him to play the experienced artist and instructor. Van Gogh was already the eccentric, fur-capped figure we can see later on in his self-portraits. He retained the asceticism of his Borinage days, eating only bread and cheese even when more luxurious food was available. In the countryside, to the astonishment of the peasants, he would squat, screw up his eyes and

Lane of Poplars near Nuenen. August 1885. Museum Boymans- van Beuningen, Rotterdam.

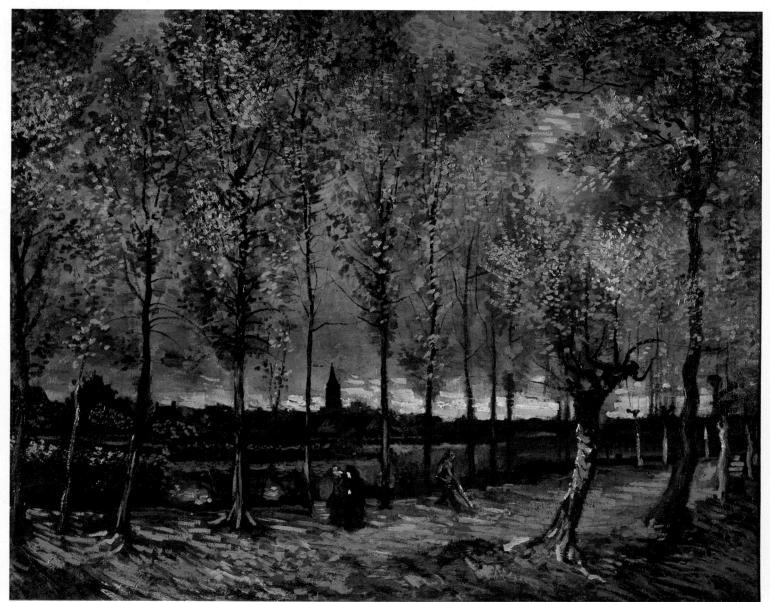

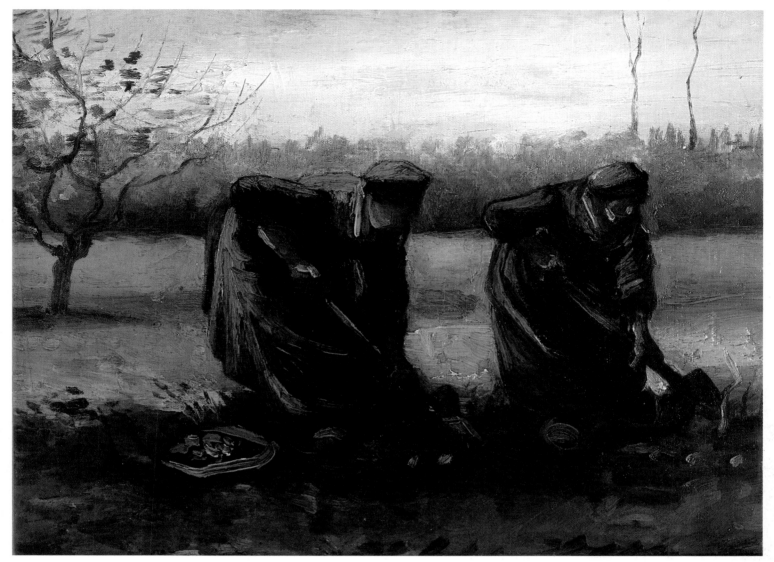

Above: *Two
Peasants Digging
Potatoes*. 1885.
Rijksmuseum
Kröller-Müller,
Otterlo.

Left: *The Old
Church Tower at
Nuenen*. May 1885.
Oil on canvas.
Rijksmuseum
Vincent van Gogh,
Amsterdam.

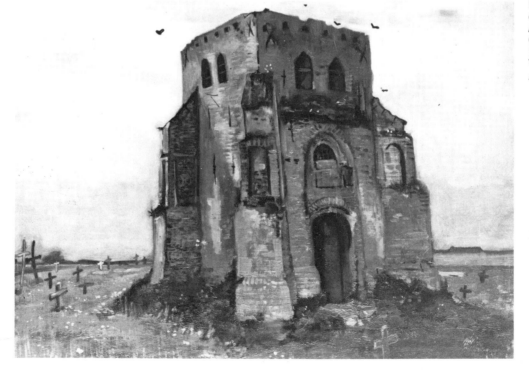

'frame' with his fingers any scene that interested him; when in Amsterdam he
would paint in the waiting-room of the railway station, paying no attention to
the onlookers, or walk about in the pouring rain, indifferent to the fact that in
his fur cap he looked – says Kerssemakers – like a drowned cat. To some extent
Van Gogh was probably playing up to Kerssemakers (he was nowhere near as
self-sufficient as he liked to imply), but the overall impression he gave – of being
determined to go his own way whatever others thought – was surely well taken.

31

Van Gogh had long signed his work with the one word 'Vincent'. When Kerssemakers asked why he did so, he received a pedestrian explanation: 'Van Gogh' was too hard a name for the English and French audiences his pictures might someday reach. Perhaps this was not the whole truth; at any rate, 'Vincent' has always seemed peculiarly appropriate, like an exposure of the self corresponding to the self-exposure at the heart of the paintings and drawings.

Eager for the stimulus of city life, Van Gogh left Nuenen for Antwerp; although he could not know it, he was never to see his native land again. In Antwerp he was admitted to the Academy of Arts as a student, with ludicrously unfortunate results. To the teachers and the other students he cut an extraordinary figure – weather-beaten, nervy and restless, outlandishly dressed in peasant blouse and fur cap, flourishing a palette made from a piece of board, and painting with lavish use of colours and extreme rapidity. A single, uncomprehending glance convinced the professor of painting that Vincent was a dunce, and he was banished to the drawing class – where he caused an uproar with a version of the Venus de Milo that transformed the Greek goddess into a healthy, broad-hipped Dutch housewife.

Van Gogh and the Academy soon parted company. A more significant experience was his encounter with Japanese prints, of which he bought a number in Antwerp, using them to decorate his room. These colourful, boldly outlined pictures violated the canons of Western art, creating a vividly patterned surface with no attempt to render spatial depth; their influence on Van Gogh was to be considerable though gradual. In this as in so many respects, Van Gogh was still the provincial artist, belatedly catching up with the taste of Paris, where Japanese prints had made their first sensational impact some twenty years before. It was therefore not surprising that Van Gogh began to set his heart on working in the French capital, where all the most exciting developments in the arts seemed to occur. Theo was markedly unenthusiastic and tried to persuade Vincent that a return to Nuenen would be better for his health; he believed in his brother's genius but can hardly have relished the idea of bringing the erratic, impossible Vincent into contact with his own private and business life.

Theo resisted by letter; Vincent acted, presenting his brother with a *fait accompli*. Late in February 1886, Theo received a note written in black crayon announcing Vincent's arrival in Paris: 'Shall be at the Louvre from midday, or sooner if you wish. Please let me know at what time you can come to the Salle Carrée.'

Square in Antwerp. 1885–86. Drawing in black crayon, done during the winter that Van Gogh spent in the Belgian city. Vincent van Gogh Foundation, Amsterdam.

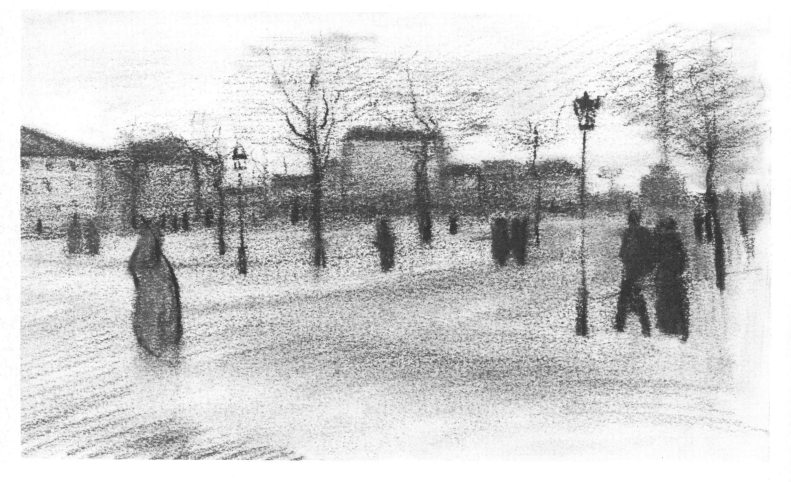

The School of Paris

Two years in Paris (February 1886 to February 1888) transformed Van Gogh. Qualitatively, there had been nothing like it in his previous experience, in terms of human contact or artistic excitement. For the first time he was plunged into a milieu where painting was taken really seriously, as a total commitment rather than as a profession for which a man might qualify by following ready-made formulas. In Paris, as at The Hague and Antwerp, the taste of the academies dominated public opinion, favouring smooth, insipid works on historical, exotic or sentimental subjects. But in Paris, Van Gogh also found a turbulent 'underground' inhabited by students and seekers whose passionate commitment matched his own, and where the most creative spirits were preaching the virtues of all sorts of new ideas and techniques. The atmosphere was heady but also dangerous: with so many influences in play, the less decisive personalities stood in danger of being overwhelmed, so that they drifted from one style to the next without making any distinctive contribution of their own. It was in Paris that

Montmartre. 1886. A painting from Van Gogh's first year in Paris, when the intense social consciousness of previous years disappeared almost completely from his work. Rijksmuseum Vincent van Gogh, Amsterdam.

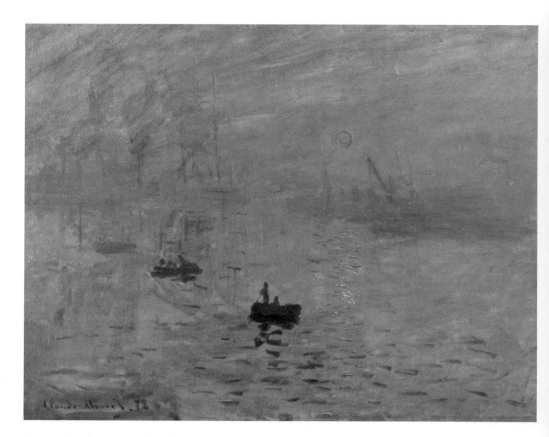

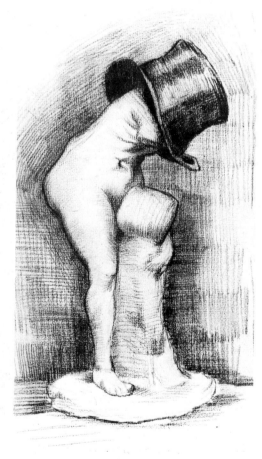

Right: Claude Monet. *Impression: Sunrise.* 1872. The painting that is said to have given 'Impressionism' its name. Musée Marmottan, Paris.

Study after a plaster statuette: a female torso with one leg and a top hat. 1886. Black chalk, executed in Paris. Rijksmuseum Vincent van Gogh, Amsterdam.

Van Gogh most clearly demonstrated his inner strength, for although he submitted to a great variety of influences, he succeeded – not without difficulty – in absorbing them all, and ultimately in evolving his own unique manner.

Although some of Van Gogh's Dutch paintings had been very dark (notably *The Potato Eaters*), he thought of himself as a relatively daring colourist. His first contact with Impressionist paintings must therefore have stunned him, though he was always curiously grudging in his acknowledgement of this particular debt. In Holland he had learned about Impressionism chiefly through Emile Zola's art criticism and his brother Theo's letters; at that time, of course, no photographic reproductions in colour existed to give him an idea of what Impressionist paintings actually looked like. His reaction to what he heard was tepid: not long before leaving Antwerp, he was still assuming that the new movement, in which landscape was so important, must be of limited significance, since '*people* are more important than anything else' and, he insisted, harder to paint as well. Van Gogh's conversion to land- and cityscapes, and the explosion of colour in his work, testify to the influence of Impressionism and succeeding movements.

Impressionism itself was no longer new when Van Gogh arrived in Paris. Public consciousness of it went back to 1874, when the first group exhibition in the Boulevard des Capucines had caused an uproar. Until this time, the only place where an artist could show his works had been at the official Salon, which generally enforced conventional standards; the mere holding of an independent exhibition constituted a gesture of defiance. But the paintings in the show caused worse offence. To critics such as Louis Leroy they were mere daubs – sketchy, worthless 'impressions' rather than proper paintings; indeed it was Leroy who gave the Impressionist movement its name, seizing contemptuously on the title of one of the exhibits, Claude Monet's *Impression: Sunrise*. The 'daubs' were the product of new techniques in the service of new aims. Monet, Camille Pissarro, Auguste Renoir and Alfred Sisley painted out of doors, working rapidly, applying small brush-strokes loaded with bright, unmixed colours in an effort to capture transient effects of light on land-, sea- and sometimes cityscapes; by contrast with the smooth surfaces and carefully toned colours of orthodox painting, Impressionist works therefore consisted of a varicoloured mass of brush-strokes that was fused by the eye into recognizable shapes. To some extent the Impressionist scape was a celebration of modern life, and especially of people enjoying themselves at regattas and outdoor dance-halls, or simply walking through fields. This modernity, rather than the 'Impressionist' technique, linked painters such as Monet with two rather older painters, Edouard Manet and Edgar Degas, who were also associated with the

movement; their subjects ranged from the race course and theatre to the modern nude – a shocking creature to the 19th-century spectator, brought up in the belief that the only respectable nude was one that came in 'classical' guise, as a newly born Venus or boar-hunting Diana.

During 1886, Van Gogh, who had once believed that there must be a shade of grey in every colour if a picture was to be harmonious, executed a series of flower paintings on the opposite principle, seeking 'intense colour and not grey harmony'. He also worked outdoors around Montmartre, where he shared a flat with Theo. The artists' quarter of Paris, Montmartre also attracted bohemians of all sorts to a colourful night-life which embraced witty cabarets, working-class dance-halls, and rip-roaring, gamey music-halls where the climax of the evening was a frenzied performance of the can-can. However, Montmartre also preserved something of its earlier character as a hill village just outside Paris, and the Butte – the Mound, as it was known locally – was still dotted with windmills and green places. These also attracted Van Gogh, who painted some views of the area in an essentially Impressionist style, but executed with a certain characteristically emphatic touch.

Soon after his arrival in Paris, Van Gogh entered the studio of Fernand Cormon; at thirty-three he still felt the need to improve his technique, as well as relishing the opportunity to work from a model without undue expense. Cormon's was an orthodox but relatively easy-going establishment. The master himself specialized in biblical and prehistoric subjects, producing a series of large, widely admired and quite absurd paintings including a *Cain* and a *Return from a Bear Hunt in the Stone Age*. Although capable of righteous wrath when his artistic canons were violated, Cormon seems to have left Van Gogh very much to

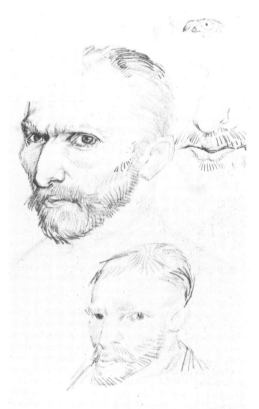

Below: Two self-portraits; fragments of a third. Summer 1887. Rijksmuseum Vincent van Gogh, Amsterdam.

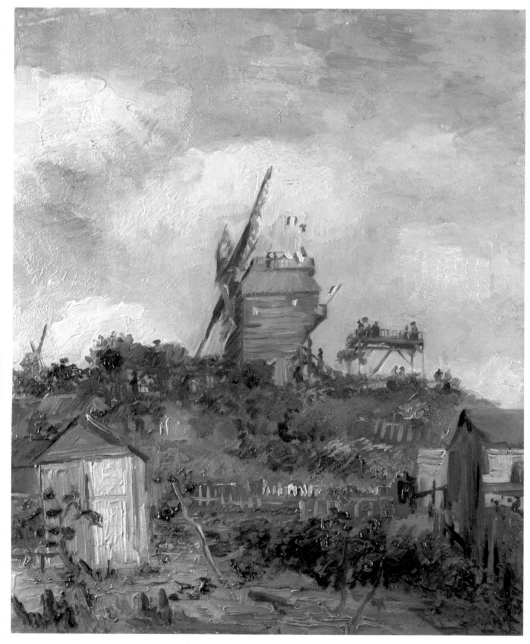

Left: *The Moulin de la Galette*. 1886. One of several Montmartre windmill views by Van Gogh, all labelled 'Moulin de la Galette' after the famous windmill-dancehall. Art Gallery and Museum, Glasgow.

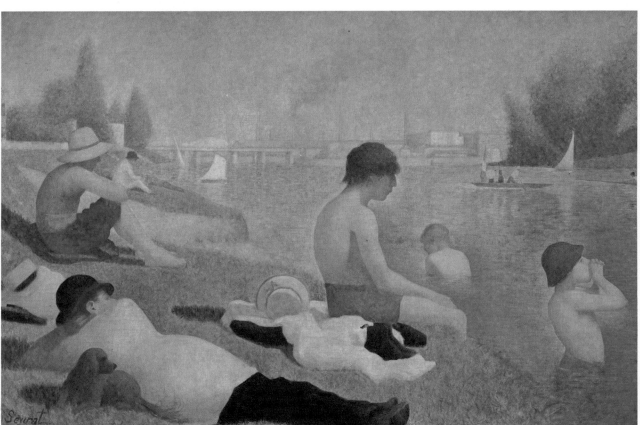

Right: Georges Seurat. *Bathers at Asnières*. 1883–84. One of Seurat's masterpieces, executed in his Pointillist technique. National Gallery, London.

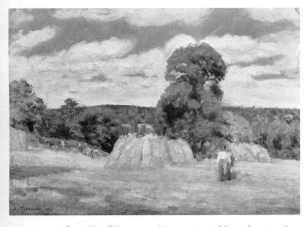

Camille Pissarro. *Harvest at Montfoucault*. 1876. A typical open-air Impressionist painting. Pissarro was the most accessible of the Impressionists, and befriended Van Gogh. Musée du Louvre, Paris.

his own devices; perhaps, like many of the students, he was a little intimidated by the wild Dutchman who worked so furiously (he even turned up in the afternoons, when the studio was empty and he could draw in peace from the plaster casts, to which his objections seem to have disappeared), and who remained aloof from the boisterous fun of his fellow-students.

Two students at Cormon's did become friendly with Van Gogh – significantly, the two most talented and purposeful young men in the place, which would not hold them for much longer. One was Louis Anquetin, often regarded at the time as the outstanding painter of the younger generation, though he never quite fulfilled his promise. The other, Henri de Toulouse-Lautrec, was to all appearances the reverse of serious – an aristocratic mocker and cynic who was already, at twenty-one, an habitué of bars, cabarets and dance-halls. Lautrec had been crippled by a bone weakness that stunted the growth of his legs, leaving him very small and grotesquely ill-proportioned. He took refuge from this misfortune behind a manner that kept at bay both pity and self-pity, while his reprehensible way of life nourished his art even as it destroyed his health with drink, sex and overwork. He was to become the unenchanted recorder of the night-life – of the dancers of the Moulin Rouge (opened in 1889), the women of the highclass Paris brothels, the famous *chansonniers* and actresses – which he immortalized with an unforgettable, cruel poetry.

Not all accounts agree on how close the friendship was between the frivolous Frenchman and the earnest Dutchman, though they exhibited together and certainly took the trouble to meet four years later, after Van Gogh's return from Arles and shortly before his death. One memorial to their friendship is a vivid pastel portrait of Van Gogh, in a style which is rather uncharacteristic of the cool Lautrec; clearly the artist felt and attempted to express his subject's tremendous inner tension. Another portrait belonging to the same period was by another acquaintance from Cormon's, the Australian artist John Russell; it is a more conventional work than Lautrec's but gives Van Gogh something of a rolling-eyed 'mad dog' look which was perhaps how he appeared to a good many people. But from this time onwards, the most fascinating record of his appearance is the artist's own: self-portraiture, previously occasional, now became virtually a habit with Van Gogh, revealing his moods, preoccupations and even something of his technical development. A self-portrait done in Antwerp makes him look older than his years, like a middle-aged, pipe-smoking labourer clad in his shabby best suit to sit for a photograph. His sombre clothing tones in with the gloomy background; the painting might serve as an illustration of the sort of thing against which the Impressionists had revolted. The Paris self-portraits

are not only immeasurably brighter, and technically adventurous in line with his other works of the period; they also show him in a surprising new light. He wears city suits and trims his beard; in one painting he is positively dapper in a light hat, fluffy light blue cravat and mauve jacket! It is possible, of course, that this was no more than a kind of fancy dress, never worn outside (Rembrandt often dressed up quite extravagantly for his self-portraits), although it hardly seems like Van Gogh to do such a thing without some serious reason. At the very least, the self-portraits express a state of mind – here, surely, a deep involvement with the Parisian way of life. Van Gogh himself wrote to an English acquaintance (and in almost faultless English): 'And mind my dear fellow, Paris is Paris. There is but one Paris and however hard living may be here, and if it became worse and harder even – the french air clears up the brain and does good – a world of good.'

Impressionism was by no means the only artistic stimulus to clear up Van Gogh's brain and do good. In fact the original Impressionists were in disarray by 1886, and there were already plenty of younger artists who owed everything to their liberating influence but nevertheless considered them to be out of date. When the eighth and last Impressionist exhibition opened in May 1886, Monet and Renoir were conspicuous by their absence, and the most scandalous works on show were in a new style, properly called Divisionism but known to most people as Pointillism, after the little dots of colour that make up most paintings of this type. The leaders of the new school were two young men, Georges Seurat and Paul Signac, and the fifty-five-year-old Camille Pissarro, a convert from the Impressionism of which he had been a pioneer. Pointillism was primarily the creation of Seurat, who claimed that it was a development of Impression-

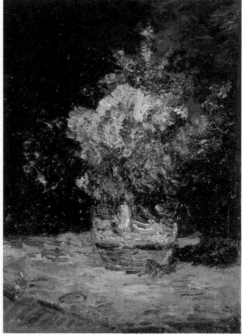

Below: Adolphe Monticelli. *Vase of Flowers*. Van Gogh had a deep admiration for the Marseilles painter Monticelli (1824–86), whose flower paintings provided him with a model. Musée Grobet-Labadié, Marseilles.

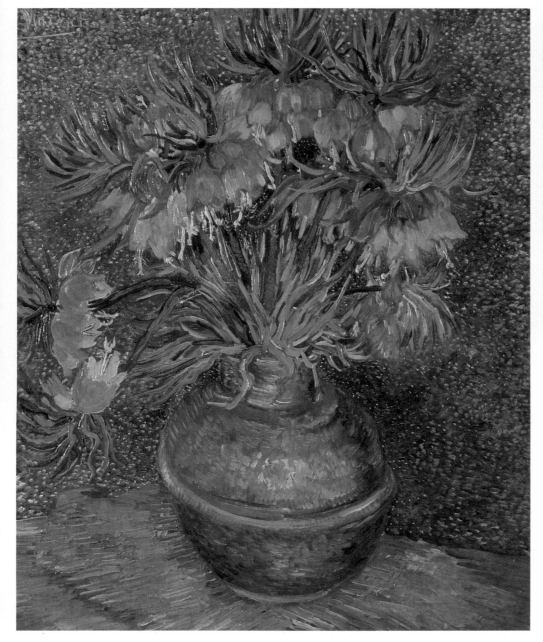

Left: Still Life: *Fritillaries in a Copper Vase*. Summer 1887. Musée du Louvre, Paris.

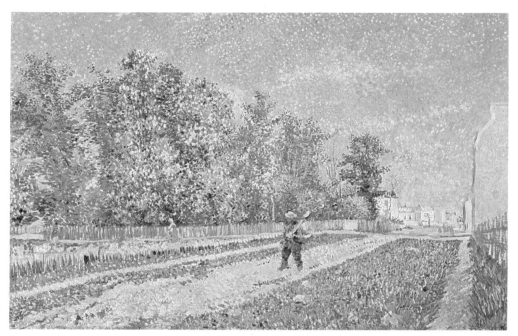

The Outskirts of Paris: Road with Peasant Shouldering a Spade. Spring 1887. Karen Carter Johnson Collection, Fort Worth, Texas.

ism (for which reason it is sometimes labelled Neo-Impressionism) that had perfected the older techniques thanks to the assistance of scientific colour theory. The Pointillist used dots or other units of pure colour to build up his picture; like the Impressionist, he relied on the spectator's eye to mix the colours when the work was looked at from a distance of a few feet; this mixing-by-juxtaposition gave the colours a greater vibrancy and luminosity than were possible with colours mixed on the palette. But unlike the Impressionist, who used rapid brush-strokes largely directed by experience and intuition, the Pointillist achieved – laboriously – a distinctive, even texture; and he believed that he achieved greater accuracy and effect through the rigorous application of scientific laws of complementarity, according to which various colour juxta-positions could be used to attain a greater or lesser impact on the eye. In the event, Seurat proved to be the only great exponent of Divisionism, although pleasant and interesting work was done by a number of his followers. Seurat's masterpieces, *Sunday Afternoon on the Grande Jatte* and *Bathers at Asnières*, are Impressionist in subject matter but utterly different in effect: the monumentally still moment he records might be eternity itself.

A technique such as Seurat's, which might involve working for a year or more on a painting, was clearly not a universal panacea. The old Impressionist, Pissarro, was to give it up after a few years, although at this time he was an

Undergrowth. 1887. Museum van Baaren, Utrecht.

ardent apologist of this new 'scientific Impressionism'. Van Gogh got to know Pissarro quite well, and seems to have learned a good deal from him. The two man shared 'left-wing' opinions, and Pissarro was the only one of the Impressionists who frequently showed peasants at work in the landscapes he painted; like Van Gogh, he had at one time been influenced by Millet. Quite apart from these considerations, the patriarchal, white-bearded Pissarro was a singularly perspicacious and helpful man with a talent for teaching; among the struggling artists he had worked alongside were the still unknown masters Cézanne and Gauguin. Pissarro later claimed he had quickly realized that Van Gogh would either go mad or go beyond all his contemporaries, but 'I didn't know he would do both.'

Van Gogh established a more direct working relationship with another Divisionist, the twenty-four-year-old Signac, with whom he regularly painted around the riverside suburb of Asnières – fresh summer views of leafy places, running water, boats, bridges and Parisians at leisure having become traditional subjects for both the Impressionist and the Neo-Impressionist. Van Gogh painted these and other subjects – a landscape with factories, an empty restaurant interior, the view from the window of his flat in the Rue Lepic – using the Pointillist technique with a distinctive and 'unscientific' freedom and emphasis. Though passionately interested in colour theory, he never fully committed himself to this or any other school of painting in Paris. Everything influenced him, but he never allowed himself to become the prisoner of a method or style.

His appreciation of Japanese prints had deepened since his days in Antwerp; their simplified forms and strong, flat colours represented a countervailing influence to the more visually 'realistic' impulse associated with Impressionism. Van Gogh haunted Bing's, the Parisian shop that dealt in orientalia; he collected and exhibited Japanese prints, and he faithfully copied a number of them. He also used a display of prints as virtually the entire background of two famous

Wheatfield with a Lark. Summer 1887. Rijksmuseum Vincent van Gogh, Amsterdam.

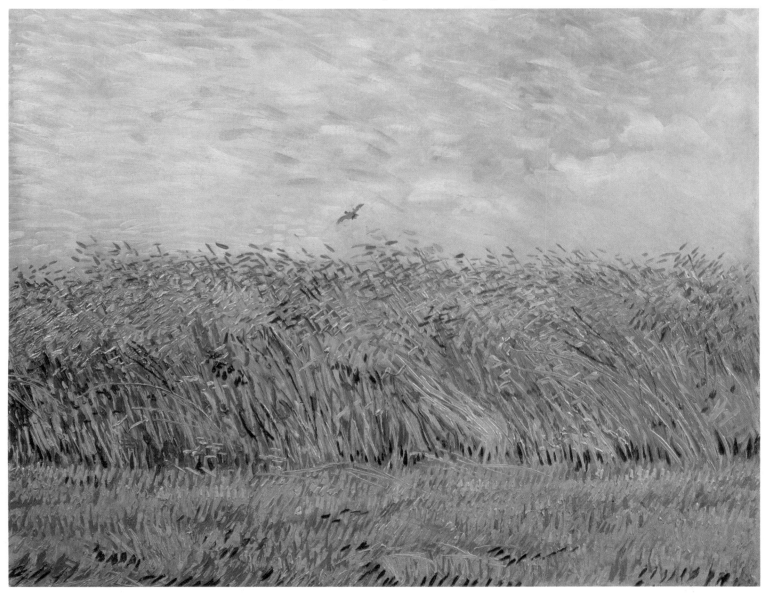

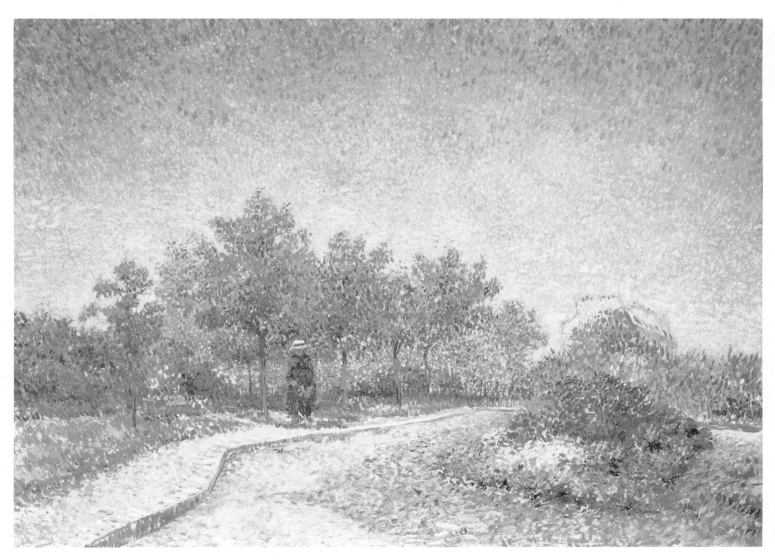

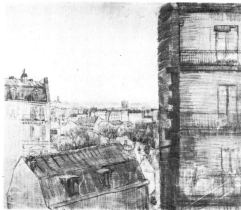

Above: *View from Vincent's Room.*
February–March 1887. Pencil and pen,
washed. A view over Paris from the
apartment in the Rue Lepic that Vincent
shared with his brother Theo.
Rijksmuseum Vincent van Gogh,
Amsterdam.

portraits of Julien Tanguy; in one (Musée Rodin, Paris) the tough little old man sits like a grizzled Buddha among geishas, blossoms and mountains seen through a screen of reeds and flying birds. Père Tanguy is one of the more curious figures in the history of modern art. He made a living by hawking artists' materials round popular painting spots, and also ran a small shop in the Rue Clauzel. Among the items on sale were paintings by all the Impressionist masters, whose work he had singled out with unfailing taste long before most supposed connoisseurs found anything in them; he even kept an unwanted supply of works by Cézanne, who was for years the most ludicrously unsuccessful of all the great artists of the period. The equally unsuccessful newcomer, Van Gogh, was also taken up by Tanguy, who fed as well as encouraged him; in return, Van Gogh painted no less than three portraits of him.

At Tanguy's in 1887, he found another friend in Emile Bernard, a young painter who had left Cormon's shortly before Van Gogh's arrival there. Bernard was as much a man of ideas as an artist, full of theories and apt to quarrel violently with those who disagreed with him or applied his theories too successfully. Inevitably Van Gogh, himself a man of ideas, was attracted to Bernard; miraculously, they never quarrelled. His experience of the artistic variety offered by Paris had broadened Van Gogh's outlook, and it was he who tried to modify the dogmatism of his young friend, who had acquired a particularly passionate detestation of Seurat and his school. Van Gogh and Bernard worked side by side at Asnières, where Bernard's parents lived, and the two men appear in a riverside photograph; in this, the only such record of Van Gogh, his back is turned to the camera.

If Bernard influenced Van Gogh at this time, the fact is not evident in the Dutchman's surviving paintings from 1887. (However, the greater part of the work he did in Paris has vanished without trace.) Bernard was already moving towards a style (*cloisonnisme*) in which detail was eliminated and the picture surface was covered with simple, strongly outlined forms so that it resembled a stained-glass window; a year later, in a more developed form, it had a considerable influence on Paul Gauguin in Brittany.

Gauguin himself was not yet a great master, and his legendary self-banishment to the South Sea Islands lay in the future. He spent most of 1886–87 out of Paris, first in Brittany, later in Panama and Martinique; but he did meet Van Gogh at some time in the autumn of 1886, and the two men made a strong impression on each other. Superficially, at least, they had much in common – most important, perhaps, being that both were late starters, a decade or more older than young artists such as Bernard and Signac. Gauguin had spent his early childhood in Peru and had been a seaman as a young man, but by his mid-twenties he had married and settled down in Paris, earning a good income as a broker's agent. For ten years he had remained a 'Sunday painter', spending his holidays working with Pissarro; then in 1883, at the age of thirty-five, he had abandoned business (which was admittedly not as good as it had been) and had determined to make a career as an artist. Since that time he had suffered for his art every bit as much as Van Gogh. His Danish wife had returned to Copenhagen with their five children, and he had experienced hunger and cold and lack of recognition; at about the time he met Van Gogh he was keeping body and soul together by bill sticking in a Paris railway station.

Both men had suffered, and both were single-minded in pursuit of their artistic goals, but there the resemblance ended. Gauguin's dedication manifested itself socially as a ruthless indifference to the feelings and welfare of other people; whether his ruthlessness did more harm than Van Gogh's more muddled impulses is another matter. Where Van Gogh was small, gingery-ugly and excitable, Gauguin was tall, saturninely good-looking and, more often than not, taciturn. Van Gogh was idealistic, a misfit who dreamed of living in a community of brother-artists; Gauguin was sensual and cynical, and, at least on the surface,

Left: *Corner in the Voyer d'Argenson Park at Asnières*. May 1887. Yale University Art Gallery, New Haven. Gift of Henry R. Luce.

Below: *The Restaurant de la Sirène, Joinville*. c. 1887–88. Musée du Louvre, Paris.

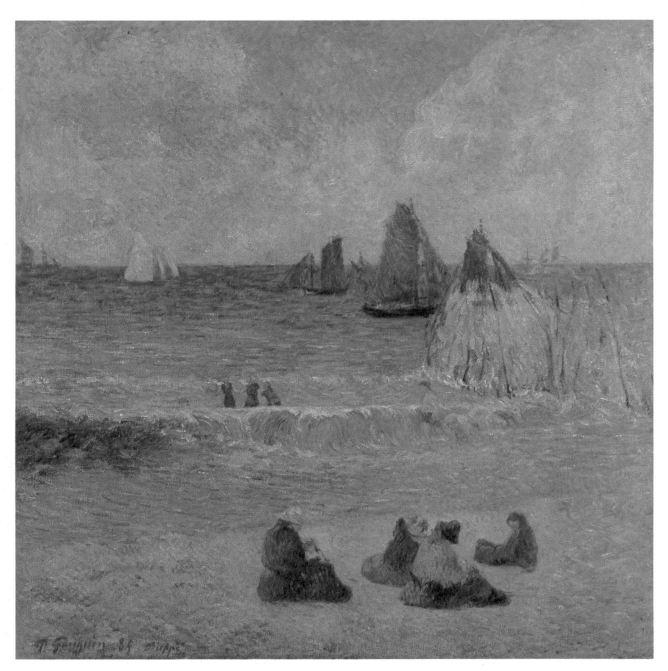

Paul Gauguin. *The Coast at Dieppe*. 1885. Gauguin, not yet the legendary South Sea Islander, became friendly with Van Gogh in Paris; their relationship was to be a fateful one. Ny Carlsberg Glyptotek, Copenhagen.

calmly self-sufficient. Almost from the beginning of their relationship there was an element of boyish hero-worship in Van Gogh's attitude towards Gauguin – an unconscious flattery that may have pleased Gauguin more than he cared to admit to himself, while it inevitably led Van Gogh to form unrealistic expectations of his friend.

During these years they met too infrequently for any conflicts to come to the surface. In 1886 Gauguin was only beginning to work his way out of Impressionism (he was one of the exhibitors at the 1886 show) towards a more decorative style. His taste for the primitive and exotic broke out at last in April 1887, when he left France for Central America where, he told his wife, he intended to live in a hut 'like a *savage*'. The reality was less romantic: he had to work as a labourer on the Panama Canal to earn enough to get away from the mainland and reach Martinique, an enchanting island on which he and his friend Charles Laval did indeed live in a hut – desperately ill with dysentery and fever, more miserable in Paradise than they had been in corrupted Europe. Finally, in November 1887, Gauguin managed to work his passage back to France. However, the paintings he brought back with him represented a definite advance. In tropical Martinique the light was strong and hard; the painter's eye was confronted with rich colours and bold forms that created scenery quite unlike the hazy summer landscapes beloved of the Impressionists. Gauguin changed his style accordingly, painting brighter pictures with more definite forms and relatively little in the way of tonal variation. This proved to be more than a temporary 'realistic' response to the different environment: the experience of the tropics merely impelled Gauguin in a direction he was ready to go, away from the 'snapshot'

style of Impressionism and towards a more decorative manner, heavy with mood, music and symbol. When Van Gogh saw Gauguin's Martinique paintings he rightly hailed them as the work of 'a poet'.

Meanwhile, in 1887 Van Gogh assumed an unexpected new role as an organizer of exhibitions. The first consisted of paintings by himself, Toulouse-Lautrec, Bernard and Anquetin. It was held at Le Tambourin, a café on the Boulevard de Clichy, whose tables and wall decorations were drum-shaped. Le Tambourin was something of an artists' haunt, and it was run by an Italian woman called La Segatori who had been a model. Rumour had it that she and Van Gogh were lovers; she may have been the sitter for *The Italian Woman*, in which Van Gogh created a painted equivalent to a certain kind of Japanese print with figures clothed in a fierce range of colours, or for *Seated Woman at Le Tambourin*, his version of a subject associated especially with Manet and Degas, the solitary woman in a café. The exact nature of Van Gogh's relations with La Segatori are not known. They soon quarrelled; in his letters, Van Gogh's comments on the consequent estrangement are cryptic, but they do have the accents of a disgruntled lover. However, his organizing enthusiasm was unaffected, and later in the year he was to put on a big show at La Fourche, a restaurant in the Avenue de Clichy; tolerant but indifferent, the patrons concentrated on their food, paying little attention to the canvases hung all round the hugh sky-lit hall. According to Bernard, Van Gogh contributed about a hundred works. The popularity of such avant-garde art can be judged from the fact that Bernard and Anquetin were pleased by their success at La Fourche: each of them managed to sell a painting.

Van Gogh was saddened by the difficulties he experienced in bringing artists together on such occasions; intrigues and petty quarrels were rife among his

The Yellow Books. 1887. Not just a composition: this is a tribute to the Parisian novelists (such as Zola and the de Goncourts) whom Van Gogh admired. Private collection, Switzerland.

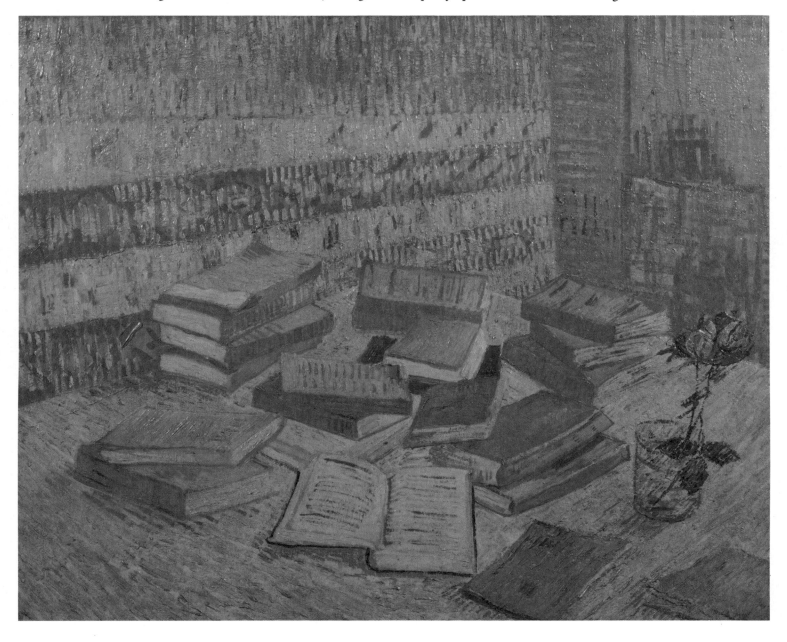

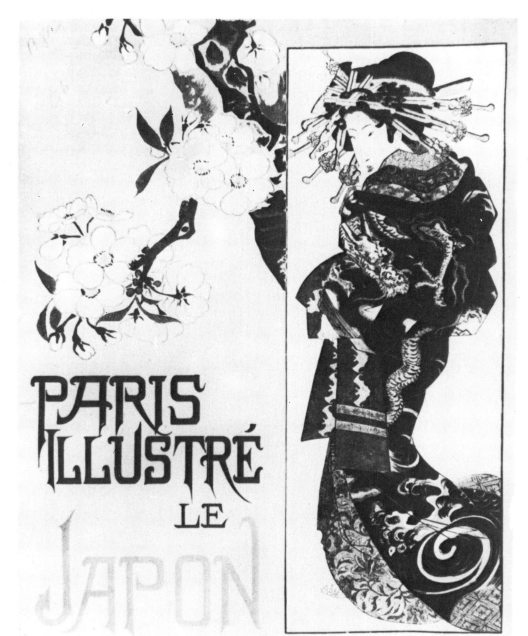

friends, and should have warned him that his dreams of founding an artists' colony might be impossible to realize. His own personality remained strange and shocking to ordinary minds. An English painter, A. S. Hartrick, remembered him as 'a rather weedy little man, with pinched features, red hair and beard, and a light blue eye', who appeared to be 'cracked' but harmless; in an argument he poured out sentences in Dutch, English and French, looking over his shoulder from his easel at his adversary and hissing through his teeth. On visits to another friend, the minor Impressionist Armand Guillaumin, Van Gogh would alternate between outbursts of rage and enthusiasm; carried away, he would lose all sense of decorum, for example stripping to the waist and giving a demonstration of how real peasants – unlike those in the unlucky Guillaumin's paintings – set about digging the soil. In almost any circumstances he was simply incapable of holding back the expression of his feelings and opinions, and his moods oscillated wildly. An illuminating but possibly apocryphal anecdote illustrates one extreme. An artist-dealer acquaintance, Alexander Reid, believing himself utterly downcast, confided his troubles in Van Gogh, and was promptly confronted with the offer of a suicide pact – whereupon Reid discovered that there were, after all, severe limits to his world-weariness, and took himself off.

Predictably, Theo found running a joint household with his 'cracked' brother an excruciating experience; and this despite the fact that three months after Vincent's arrival they were able to leave Theo's flat in the Rue Laval for a larger apartment in the Rue Lepic, higher up the Butte, from which there were splendid views right across Paris. (Among Van Gogh's surviving paintings from this period is a *View from Vincent's Room*.) Like everybody else, Theo had troubles of his own, including a mistress who moved in while he was away on a

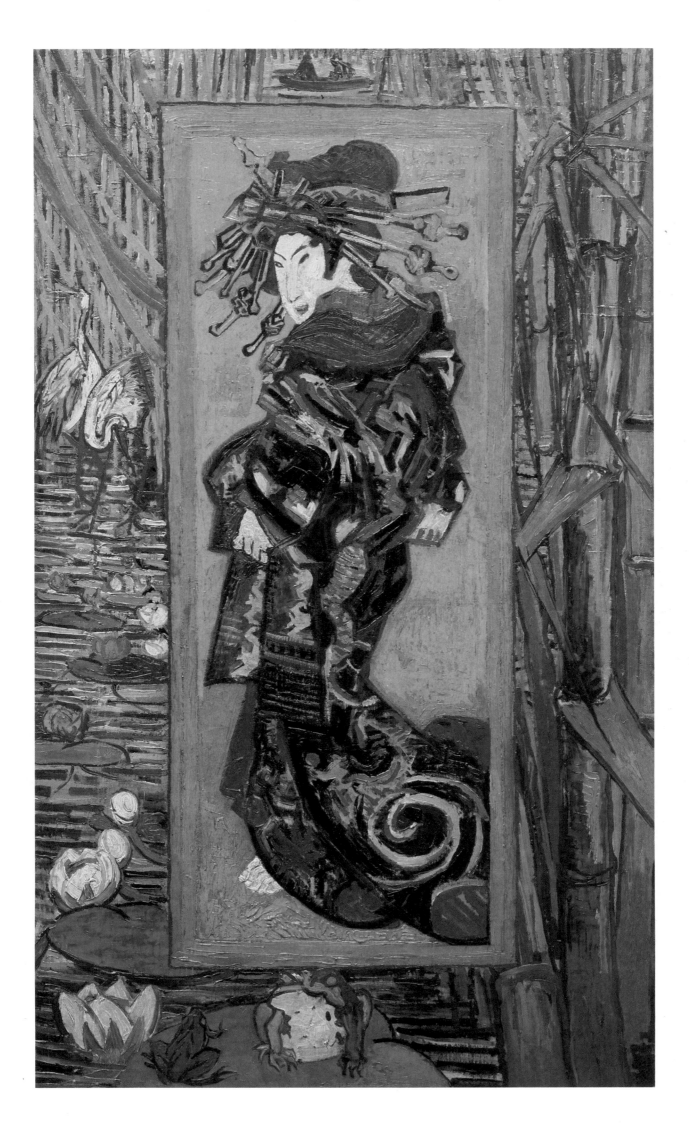

Left: Paul Gauguin. *Martinique Landscape*. 1887. During his brief and miserable stay in Martinique, Gauguin found a world of strong colours that appealed to his temperament more than Impressionism: like Van Gogh he was to develop a distinctive, bolder, more expressive style. National Gallery of Scotland, Edinburgh.

Above: Henri de Toulouse-Lautrec. *Portrait of Emile Bernard*. 1885. Bernard was a close friend of Van Gogh, and became an important link between the Dutchman and Gauguin. Toulouse-Lautrec, a sardonic, crippled genius whose paintings record the garish glamour of Parisian nightlife, was also on good terms with Van Gogh. On one occasion he was almost involved in a duel through defending his friend's work. Tate Gallery, London.

trip; at some point in the obscure ensuing complications, Vincent offered to take her over and, if necessary, marry her. The crisis was resolved somehow or other, and it was the day-to-day difficulty of living with Vincent that actually wore Theo down. Himself indifferent to worldly considerations, Vincent was incredibly untidy, littering the entire apartment with tubes of paint, drawing materials, canvases and other evidences of his working life. If Theo dared to bring home friends in spite of the mess, the evening turned into a debate or a harangue, always ending in a quarrel; and Theo was soon complaining that no one wanted to come and see him any more. Surrounded by money-minded associates all day and expatiating artists all evening, he felt lonely for ordinary, pleasant social relationships; he wished that Vincent would move out but, believing in his brother's artistic vocation, refused his sister's suggestion that he should withdraw his financial support and leave Vincent to fend for himself. To Theo, his older brother seemed like a man with two souls in a single body, at one moment delicate and tender, at the next hard-hearted and egoistical.

Tensions between himself and Theo may have helped decide Vincent to leave Paris. To make matters worse, towards the end of 1887 he had entered a phase of general depression and irritability so acute that he even found it difficult to persuade models to sit for him; he had become disgusted with the self-seeking and intrigues of his fellow-artists, and he was drinking heavily. A famous self-portrait from the period seems to reflect this mood; although still remotely related to Japanese and Pointillist works, it is nevertheless a painting of great intensity and originality in which a web of dense, rhythmically patterned brush-strokes lead the eye restlessly all over the picture surface, creating a brilliant and deeply uneasy effect.

Far left: *Japonaiserie: The Flowering Plum Tree*. 1887. For this Van Gogh copied a print by the great Japanese master Hiroshige. Rijksmuseum Vincent van Gogh, Amsterdam.

The Italian Woman. Late 1887 or early 1888. The woman may be La Segatori, a café owner with whom Van Gogh is said to have had a love affair. Musée du Louvre, Paris.

Right: *Self-portrait in front of an Easel*. January or February 1888. Van Gogh's figure in this painting seems to radiate determination; he was about to make a fresh start by leaving Paris for the South. Rijksmuseum Vincent van Gogh, Amsterdam.

It was time for a change; Van Gogh had once more reached a point at which he felt a loathing for the city and longed for a simpler life. His friend Gauguin was about to leave for his old haunts in Brittany, but Van Gogh decided that he wanted no more of the familiar North. Inspired by his admiration for Japanese prints, and perhaps by the artistic benefits that had visibly accrued from Gauguin's trip to Martinique, he became attracted to the strong colours of the South of France – the Midi – which, he told his friends, would be *his* Japan. In time, Bernard, Gauguin and others might join him in a mutually supportive community ... A final self-portrait, done in January or February of 1888, shows a distinct change in Van Gogh's self-image. The frenzy of the brush-work has subsided; Van Gogh's figure takes up most of the picture surface, looking larger and sturdier than in previous self-portraits, and radiating a dogged determination. The Parisian hat and suit have given way to a rough tunic; Van Gogh confronts us specifically as a painter, holding a varicoloured palette and standing in front of an easel supporting an unseen canvas.

The prospect of Vincent's departure revived the brothers' mutual affection, and they parted on excellent terms. Vincent had an almost superstitious feeling for the way in which furnishings embody the personality of their owner, and with Bernard's help he arranged his room – with Japanese prints on the wall and his own canvases stacked here and there – in such a way that Theo might still feel his presence.

On about 20 February 1888, Van Gogh took a train from Paris. For the time being, at any rate, he intended to try his luck in the southern city of Arles.

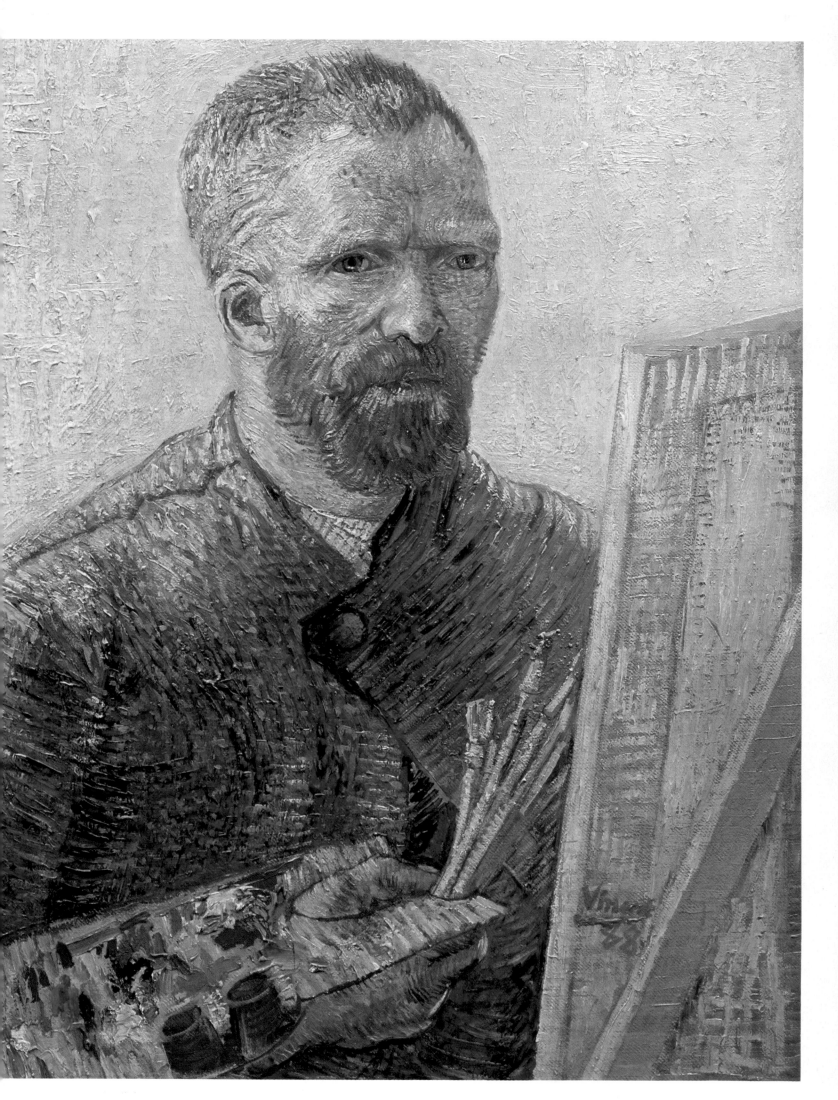

Arles: Triumph and Tragedy

When Van Gogh arrived at Arles, the town looked more like something out of a Japanese print than he had expected: there had been an unusually late fall of snow and the landscape was gracefully decorated in tones of white. Within days the promise of the South began to be fulfilled. Van Gogh found himself truly 'in Japan' as the almond trees began to flower, an unforgettable sight for the colour-hungry northerner. He was painting a flowering tree – in this instance a peach – when he heard that his old teacher, Anton Mauve, had died. Remembering how much Mauve had helped him, Van Gogh entitled the painting *Souvenir de Mauve* and sent it to the painter's widow.

To paint flowering trees, with their delicate, varicoloured leaves, Van Gogh used a technique that still owed a good deal to Impressionism. But the South hastened his development away from the essentially northern preoccupation with the inconstant play of light and the subtle interaction of colours in the misty atmosphere. Southern sunlight – pale sulphur or lemon-gold, said Van Gogh – created a different world. In his new surroundings he found a starkness of form and brilliance of colour that influenced him in much the same way as the tropics had influenced Gauguin. In his early summer landscapes, and in paintings such as *The Langlois Bridge* and *Boats at Saintes-Maries*, Impressionist 'atmosphere'

View of Arles. April 1889. Bayerische Staatsgemäldesammlungen, Munich.

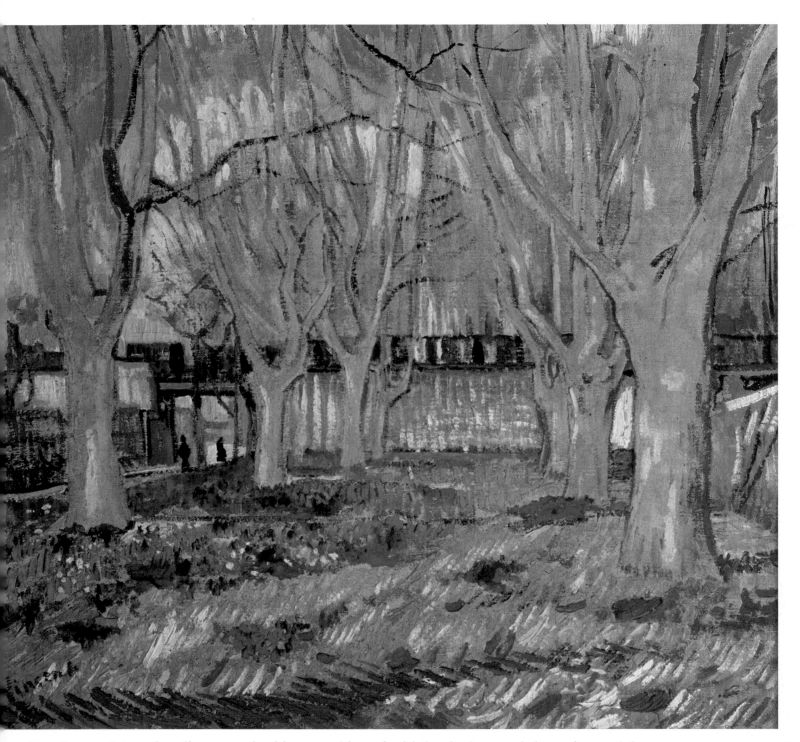

Plane Trees at Arles.
March 1888. Musée
Rodin, Paris.

has disappeared; objects are 'drawn' with hard edges, and the entire work has become clear, colourful and decorative.

At the same time, Van Gogh began to explore new concepts of colour harmony. In May he took over part of a house to use as a studio and store for his equipment and paintings; this was the famous 'yellow house' that Gauguin was later to share with him. Here he painted a still life – a coffee pot, jugs and cups on a table – which was executed solely in a range of blues and yellows. His further experiments with harmonies based on one or two colours culminated in the famous *Sunflowers* series, which must be among the most popular paintings of all time, reproduced in unguessable numbers and hung on walls all over the world. Nowadays we hardly notice that they are in fact harmonies in yellow, including only an unavoidable minimum of any other colour.

But, with the summer days growing longer, most of Van Gogh's painting began to be done outdoors. He laboured ceaselessly, once more in 'a rage of work', completing a canvas – sometimes two canvases – in a single day. Although he ignored Arles' splendid Roman remains and had little more time for its Romanesque cathedral, Saint-Trophîme, he was ardent in his search for more ordinary motifs that might evoke a response from him. The locality was a particularly varied one, and Van Gogh found inspiration in fields, orchards, tree-lined avenues, cottages, rivers and canals, bridges, barges and boats, as

well as in the cafés and houses of the little town where he lived. He tramped all over the countryside, working in many places, but he also returned again and again to certain spots. At Montmajour, for example, there were rocky crags and views of the countryside from a height; at Saintes-Maries there was a castellated church and the Mediterranean – always a moving sight for a northerner – lapping at a shore on which fishermen worked at their nets and boats were beached.

In the Midi, Van Gogh's years of relentless self-instruction began to bring substantial results, enabling him to paint with an astonishing facility and rapidity; and this in turn made it possible for him to get onto canvas the special emotion created by each subject before the feeling became dulled. However, his approach to his work was certainly not purely intuitive: he identified promising subjects while out walking, and seems to have worked out the required treatment before returning to the spot with his easel; furthermore, as we have seen, he often painted a single subject many times, thus increasing the element of premeditation in his approach. But the act of creation itself now became rapid in the extreme. Instead of making preparatory sketches and studies in orthodox fashion, Van Gogh 'drew' directly onto the canvas with his loaded brush, sometimes even squeezing the paint directly onto the surface from the tube. Conscious of his originality, he cautioned Theo against undervaluing such rapidly executed works, explaining that the brush-strokes now came from under his hand as naturally as sentences from his lips; he found everything about him so absorbing that 'I let myself go without thinking of any rules.'

The surface textures of his works, which had always tended to be emphatically visible, became an increasingly important element in the picture-patterning;

Souvenir de Mauve. 1888. Van Gogh was painting this study of peach trees in blossom when he heard that his old teacher, Anton Mauve, had died. He gave the painting its present title and sent it to the widow. Rijksmuseum Kröller-Müller, Otterlo.

The Drawbridge at Arles ('Pont de Langlois'). March 1888. Rijksmuseum Kröller-Müller, Otterlo.

stippled, criss-crossed or long linear brush-strokes formed complements and contrasts that reinforced the effects achieved with colour and outline, compelling the spectator's eye to dwell on a particular place or move across the surface in accordance with the painter's intentions. Van Gogh was able to achieve similar effects in the drawings he made at Arles, substituting patterned masses of pen-strokes for the texture of paint. Using a variety of instruments, including the highly expressive oriental type of reed pen, he created drawings in which shaded areas of widely different kinds – straight and criss-crossed hatched strokes, curls, dots and undulating lines – jostle one another in a dynamic harmony. These strikingly original works were also executed with practised rapidity, and hardly seem related to the still stiff and laborious drawings that Van Gogh had been producing as little as three years before. In both painting and drawing, his encounter with the South had precipitated an astonishing, unreasonable breakthrough into mastery.

Boats on the Rhône. 1888. Museum Folkwang, Essen.

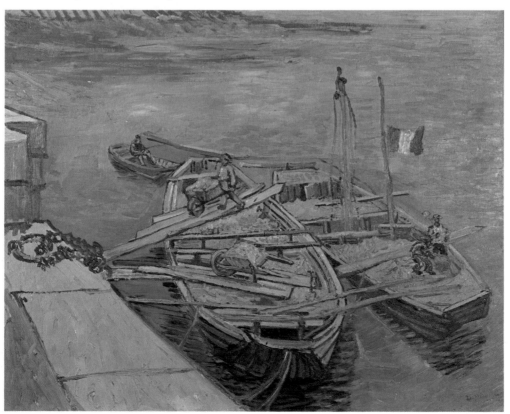

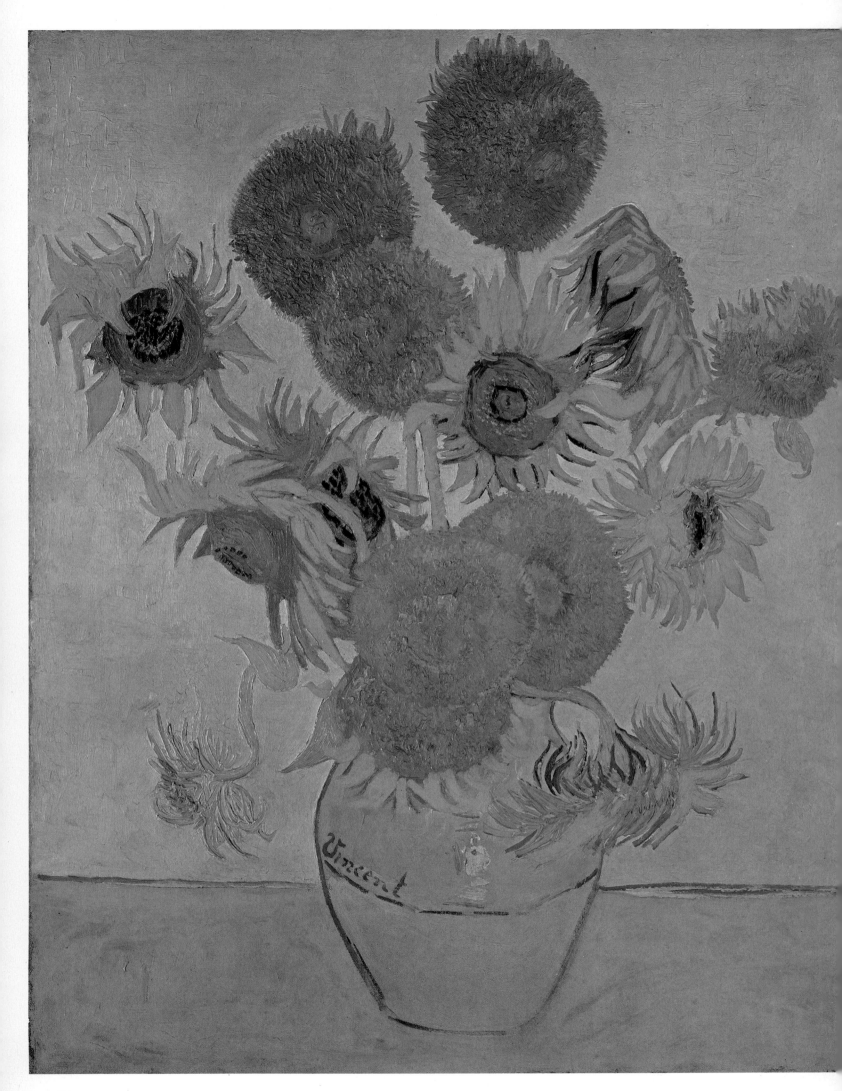

Van Gogh himself realized that he was making significant progress. His letters to his brother convey an unmistakable sense of liberation, and although he still had sharp things to say about many of his Parisian acquaintances, he seems to have been happier; certainly there was no trace of his former touchy and suspicious attitude towards Theo. All the same, there were latent dangers in the fact that he had made few friends at Arles. Perhaps the best was the postman, Armand Roulin, a large, full-bearded fellow whose portrait Van Gogh painted as a harmony of blues. Less sympathetic but intellectually closer was Milliet, a lieutenant in the Zouaves, a regiment whose rank and file consisted of colourfully uniformed Algerians. (Van Gogh painted one of them – a bugler – resplendent in tunic, skirts and baggy hat.) Milliet was himself an amateur artist, and went out with Van Gogh on sketching trips. He admired his friend's drawing but

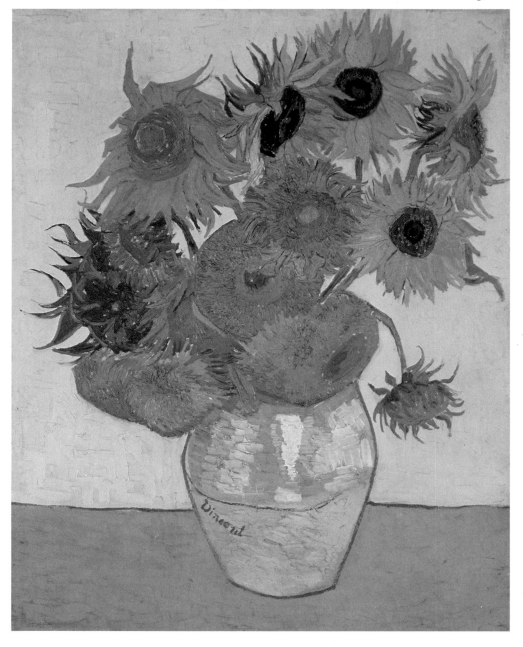

Left: *Sunflowers*. 1888. One of the famous series by Van Gogh, nowadays so familiar that we hardly realize it is a startling 'harmony in yellow'. National Galley, London.

Vase with Twelve Sunflowers. August 1888. Bayerische Staatsgemäldesamm- lungen, Munich.

thought his painting so bad that he would move away while Van Gogh was working rather than be forced to venture an opinion; besides, he later recalled, when Vincent got into an argument and lost his temper, he was like a madman. To Milliet's conventional mind, the absence of drawing in Van Gogh's paint- ings was precisely what made them absurd; colour was simply not a substitute. Not surprisingly, he even disliked Van Gogh's portrait of him – not the first instance in the history of painting of a spurned immortality. By orthodox standards the drawing was indeed 'childish' and the colouring outrageously crude, setting the red-capped, blue-uniformed officer against a heavily impasted, strong green background that must have seemed to him like a deliberate outrage.

In midsummer Van Gogh encountered two young visitors to Arles whom he had known at Cormon's studio in Paris. One of them, the Belgian painter

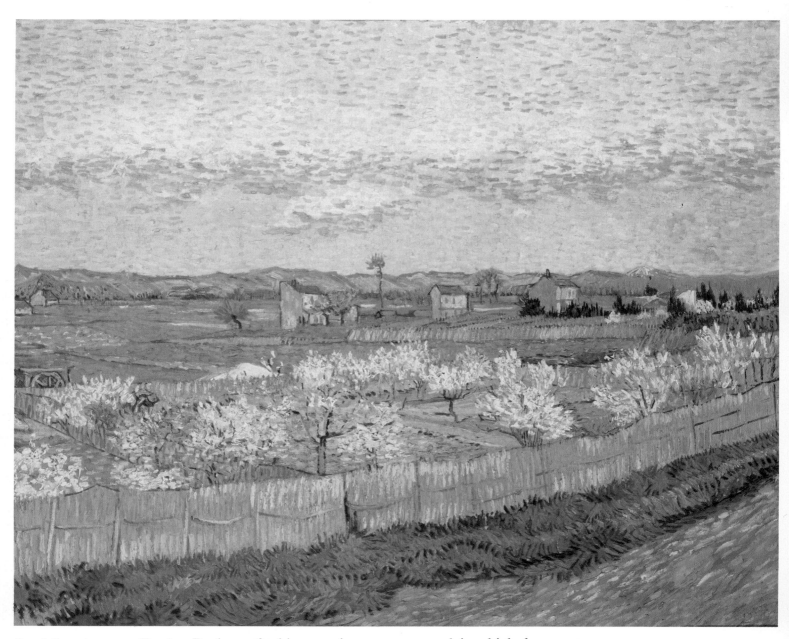

Eugène Boch, sat for his portrait – a strange work in which the gaunt, conventionally dressed Boch is set against a starry sky of deep, intense blue. Van Gogh's descriptions of the painting show his preoccupation with the expressive or symbolic possibilities of his art. Boch was to represent a figure whom Van Gogh had long dreamed of painting: the poet. The light head against a deep blue background would give an effect of mystery – would itself seem star-like. To attain such an effect, 'I shall become an arbitrary colourist', for whereas the Impressionists and others sought to reproduce reality, 'I use colour more arbitrarily, in order to express myself more forcibly.'

This might be called the manifesto of modern expressionism, but it is also evidence of an underlying continuity in Van Gogh's artistic intentions. As a younger man he had repeatedly voiced his admiration for an art which spoke from soul to soul, though he then believed it was to be found in a form of social realism heavily laden with pathos. At Arles, through his use of 'arbitrary' colour for expressive or symbolic purposes, he again sought to speak from the soul. In one sense, then, he was correct in believing that Paris and Impressionism represented a deviation from his chosen path; but when he stated that 'What I have learned in Paris is leaving me' he, of course, overlooked the very liberation of colour on which his mature art had been based. (From first to last, Van Gogh tended to undervalue Impressionism and his own debt to it. Since the Impressionists scarcely dominated Paris at the time, this attitude cannot be explained by provincial resentment or younger-generation jealousy, and therefore remains something of a puzzle.)

For all its ancient glories, 19th-century Arles was no more than a little provincial town, utterly conventional and inward-looking in its attitudes. If Parisian artists such as Guillaumin found Van Gogh's behaviour odd, it is

hardly surprising that most Arlesians regarded him with suspicion, and that portrait subjects were hard to come by. His paintings must have seemed baffling and his working methods bizarre – especially when the days began to grow shorter and Van Gogh turned his unspent energies to painting at night. Outdoors, in order to see what he was doing, he stuck lighted candles to the top of his canvas and also in his hat. This eccentric system justified itself in that it enabled Van Gogh to create such masterpieces as *Café Terrace at Night*, *Arles* and *The River Rhône at Night*, although it must have made the local people even more distrustful of the wild Dutchman in their midst.

To assuage his sense of isolation, Van Gogh drank, smoked and wrote long letters to Theo. He also kept in close contact with his friends Gauguin and Bernard. Shortly before Van Gogh's departure for Arles, Gauguin had retired to Pont-Aven in Brittany; in August 1888, Bernard followed suit, and for the first time the two men formed a close association. Their relationship had its paradoxical side: Bernard was overawed by the strength of Gauguin's talent, yet it was the younger man who took the lead when it came to stylistic innovation.

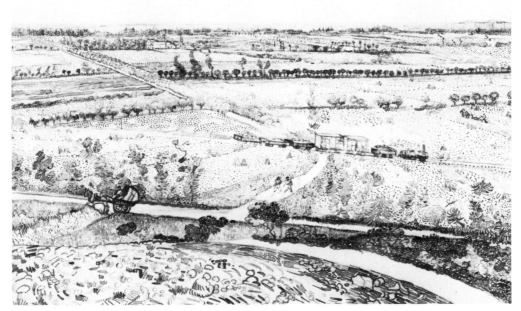

Landscape near Montmajour, with the Train from Arles to Orgon. July 1888. Drawing done with a reed pen and black chalk. British Museum, London.

Bernard encouraged Gauguin to take much further the elimination of detail from his paintings, and at the same time to give them a certain symbolic and religious content; Gauguin's *Vision after the Sermon* is the best-known example of his work during this period. Through the letters that passed between Pont-Aven and Arles, Van Gogh was able to follow his friends' artistic development and keep them informed of his own struggles. The sympathy between the three was also expressed in the form of an exchange of portraits, a Japanese custom which appealed to Van Gogh's enthusiasm for artistic fraternity. Gauguin and Bernard were supposed to paint each other and send the results to Van Gogh, but neither felt quite up to it (Bernard frankly admitted that he found Gauguin too formidable a subject). Instead, each painted a self-portrait that included a little sketch of the other and a dedication to their friend, Vincent. Gauguin's painting was entitled *Les Misérables*, and was accompanied by an elaborate explanation to the effect that it was a portrait of the artist as a victim of society. Perhaps inspired by this self-dramatization, Van Gogh painted the most bizarre of his self-portraits, which he described as 'almost colourless', and dedicated it to Gauguin. Gaunt, slant-eyed and shaven-headed, the Van Gogh of this painting radiates a fanatical intensity, his strangeness emphasized by placing him in front of a pale green background. In a letter to Theo, Vincent explained that the portrait was, like Gauguin's, an exaggeration of his own personality, intended to represent the artist as an utterly dedicated figure – 'a bonze [Buddhist monk], a simple worshipper of the eternal Buddha'.

This portrait was as serious as Gauguin's but less despairing, he told Theo. And it held its own when compared with Gauguin's work; Van Gogh's satisfaction on this point suggests that he felt a certain concealed sense of rivalry with his friend. On the surface, however, he continued to hero-worship Gauguin,

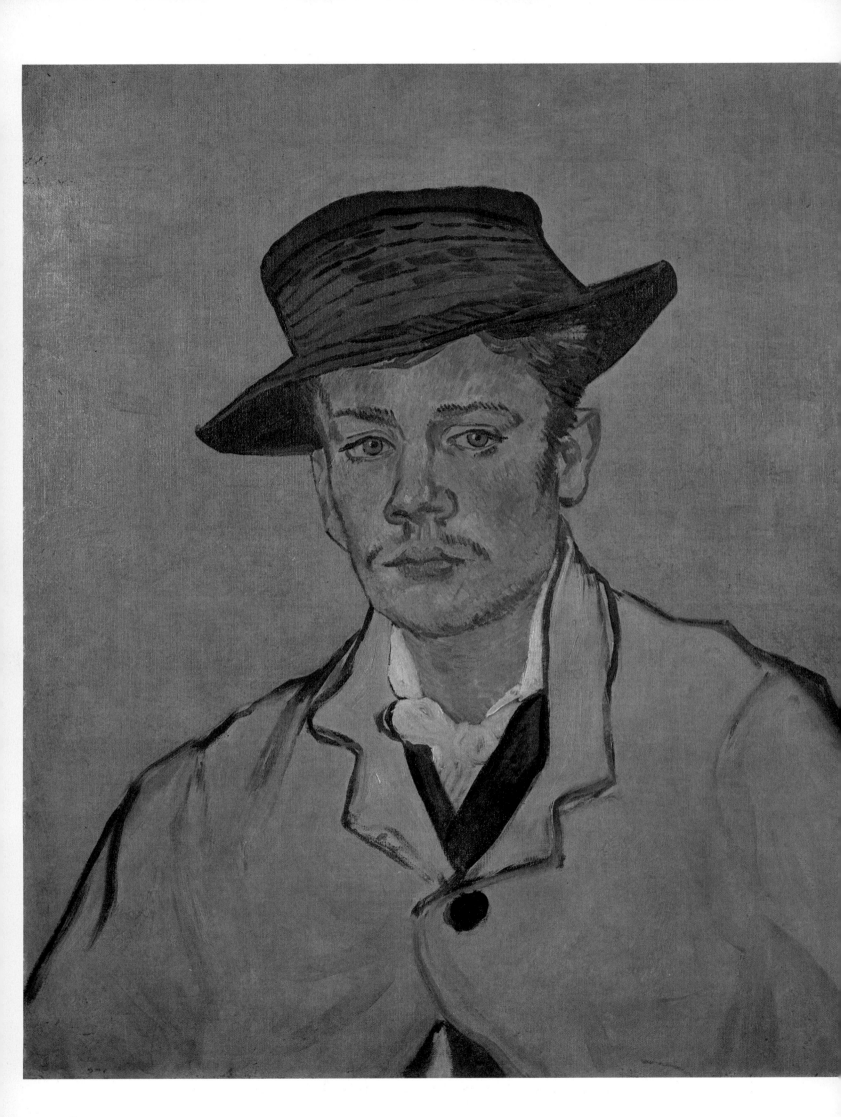

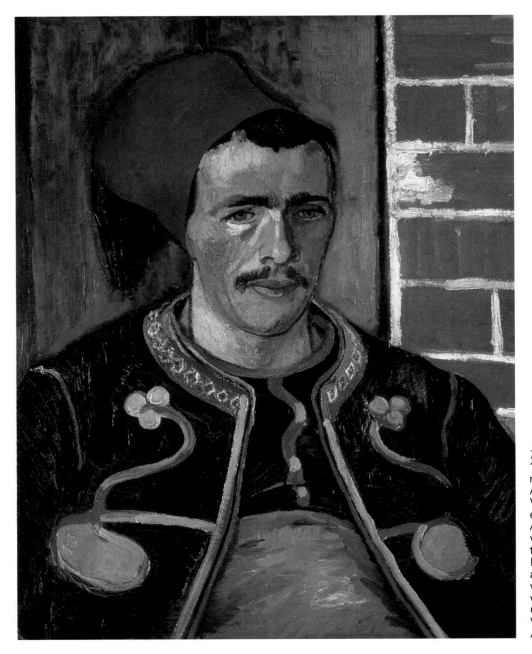

The Zouave. June 1888. The Zouave regiment of Algerians provided Van Gogh with exotic subjects at Arles; for a time he was friendly with the Zouave Lieutenant Milliet, an amateur painter who sometimes worked beside Van Gogh. Rijksmuseum Vincent van Gogh, Amsterdam.

encouraged by a similar attitude on the part of Bernard. Enchanted by the rich colours of the Midi, he resisted the temptation to join his friends at Pont-Aven; but he pressed Gauguin to make the journey to Arles and become head of a 'studio of the South'; Bernard, Laval and perhaps others could follow later.

This idea soon became an obsession with Van Gogh, given added urgency by the imminent prospect of spending a long, lonely winter in Arles. Gauguin's attitude was no more than lukewarm, and there were also great practical difficulties, including the substantial debts he had incurred at Pont-Aven. Once more it was Theo who came to the rescue. Having received a small legacy, he was able to solve Gauguin's financial problems by contracting to pay him 150 francs a month (the same amount as he sent Vincent) in return for twelve paintings a year. This and other inducements eventually persuaded Gauguin to make the trip to Arles where, subsidized by Theo, he hoped to save enough for another venture to the tropics. Alternatively, he would stay at Arles until he 'arrived'; for he was convinced that Theo must have put him under contract after a shrewd appraisal of his commercial potential, and would now 'push' his work for all he was worth. Van Gogh's dream of a studio of the South hardly figured in any of these calculations.

From the first, then, Gauguin's attitude was unpromisingly cool. By contrast, Van Gogh lived and worked in a condition of permanent over-excitement that only intensified as the time of his friend's arrival approached. Drinking too much and eating too little, he worked so relentlessly that he began to suffer from fainting fits. He was absolutely determined to create a body of work that would establish his individuality beyond question; then, he felt, he would be able to benefit from Gauguin's influence without any danger of becoming a mere

imitator like Gauguin's friend Charles Laval. Although Van Gogh undoubtedly succeeded in his aim, the price was high: the very masterpieces he created bear witness to the mental strain he was under. His self-portrait for Gauguin was strange enough, and it is probably not coincidental that, a few weeks after painting himself as a bonze, he was comparing himself with the 15th-century artist, Hugo van der Goes, whom he described (accurately) as a 'mad painter monk'. *The Night Café*, a work discussed earlier, belongs to this period and is even more disturbing. It expresses 'the terrible passions of humanity' through its clashing reds and greens, and may have been influenced by Van Gogh's reading of an article about the Russian novelist Dostoevsky, who was in many respects a kindred tormented spirit; but when Van Gogh wrote to his brother that he had tried to show the café as a place where a man might ruin himself, or go mad, or commit a crime, it is clear that he spoke with the authority of a mind already at risk. His calmest works from this period were those associated with the friendly home he was trying to create, notably *Vincent's Bedroom* and *The Yellow House*.

When Gauguin arrived in Arles on 23 October 1888, Van Gogh seems to have greeted him with an ingratiating mixture of delight and timidity. For a few weeks, at least, the normally obstinate Vincent was so anxious to please that he agreed with all his friend's opinions and fell in with all his plans; he even

Below: Emile Bernard. *Breton Women in the Fields*. 1888. Private collection.

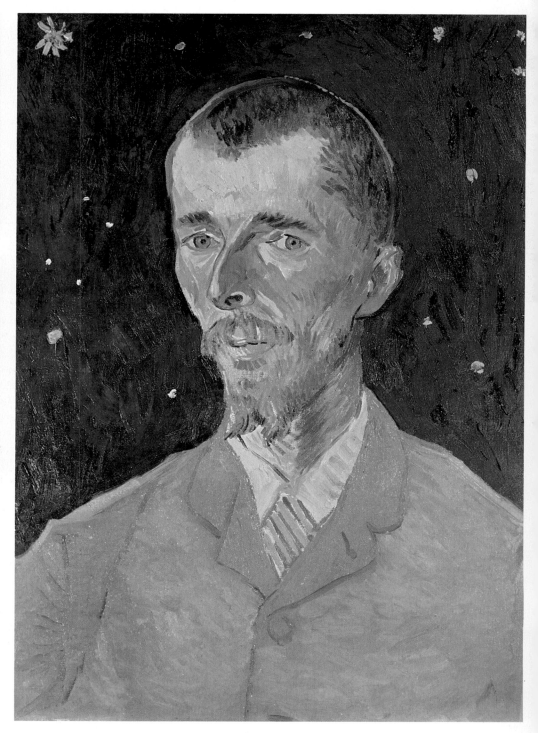

Above: Paul Gauguin. *The Vision after the Sermon*. 1888. The strong, flat colours, elimination of detail and bold outlines of this painting mark Gauguin's final break with Impressionism. Although the more talented, he owed much to the stylistic influence of his young friend Bernard. National Gallery of Scotland, Edinburgh.

Right: *The Poet*. September 1888. In this portrait of the Belgian painter Eugène Boch, Van Gogh used a non-naturalistic style to convey a sense of mystery. He was closely in touch with his friends Bernard and Gauguin, who were experimenting in a similar direction. Musée du Louvre, Paris.

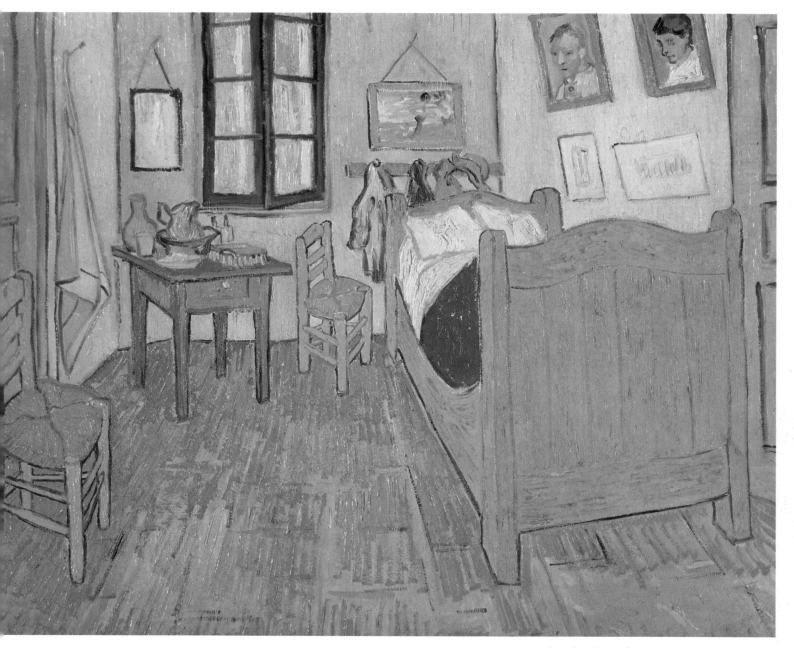

Vincent's Bedroom.
1889. Van Gogh
originally painted
this subject – his
bedroom at Arles –
before Gauguin's
arrival in October
1888. This and
another copy (both
virtually identical
with the original)
were made while
Van Gogh was an
inmate of the
asylum at Saint-
Rémy. Musée du
Louvre, Paris.

allowed himself to be persuaded that Pont-Aven was a more suitable place for a painter than Arles, and that the studio of the future would, after all, be set up in Gauguin's beloved tropics. Gauguin moved into the yellow house, cleared up the mess, worked out a budget for the household, and arranged for Van Gogh and himself to eat cheaply at home instead of at a café; Van Gogh shopped, while Gauguin did the cooking. Gauguin was caustic about Vincent's way of life, although he later recalled that there was, none the less, a quality of evident brilliance in both Van Gogh's paintings and the words he spoke.

Gauguin, the ex-sailor, proved to be a good cook and, when he was in the mood, no mean teller of tales about life at sea and the cruel beauties of the tropics. Van Gogh played up to him with unconscious flattery, wholeheartedly accepting Gauguin's self-projection as a kind of noble savage; he wrote of him to Theo as a 'virgin creature' dominated by blood and sex.

Then disillusion began to set in. Gauguin's budgeting was efficient, but according to Van Gogh he was apt to ruin it by indulging in impulsive sprees. Some of his doings shocked Van Gogh – who does not, however, specify what they were in his surviving letters. Jealousy may have played a part in his attitudes: Gauguin's considerable success with women was probably more of an irritant than any money he spent, especially since Van Gogh's sexual powers seem to have been on the decline as a result of all his self-deprivations. At the same time, Gauguin appeared to be gaining the recognition still denied to Van Gogh: in November 1888 Theo arranged an exhibition of his works and managed to sell some. The tensions between the friends came out in their arguments about the history and practice of painting. In retrospect, we can see that each man simply upheld theories that justified his own practice, and praised those older masters

who appealed to his own temperament. So Van Gogh extolled passionate colourists such as Delacroix and socially aware artists such as Millet and Daumier, while Gauguin championed the cool masters of line, Raphael, Ingres and Degas. From everything we know of Van Gogh it is likely that such discussions became intense and protracted, ending in the nervous prostration of both parties; by his own account, Gauguin often reached a point at which he pretended to agree with Van Gogh simply in order to keep the peace.

In spite of their disagreements, both artists were highly productive during their two months together at Arles. They made working trips into the country-side, painting an alley of poplars and the vineyards, albeit from different points of view and in different styles. When the weather became too bad for painting outdoors, they worked together in cafés and also in a local brothel. (It was thoroughly 'modern' to do so, and Degas and Toulouse-Lautrec were among the other artists to exploit this new subject.) They painted the portraits of anyone who could be persuaded to sit; sometimes both painted the same person, for example Madame Roulin, the postman's wife, and a Madame Ginoux, 'L'Arlésienne', who wears local costume in the various portraits of her.

In the event, Gauguin's influence on Van Gogh's work was less than might have been expected. Van Gogh's *Dance-hall at Arles* represents an attempt at the flatly coloured, cleanly outlined *cloisonniste* style, here perhaps more reminiscent of Bernard than of Gauguin; however, Van Gogh's choice of subject creates a mood that has little in common with his friends' taste for cool and mysterious effects. His finest works all represent an emotional response to something seen; where Gauguin drew on memory and imagination, painting Breton women among the vines of the Midi, Van Gogh felt that he needed the stimulus of reality, and at this time his response was usually realistically accurate in everything but his use of colour as a medium of emotion. He did try Gauguin's

The Yellow House. September 1888. A view of the house at Arles that Van Gogh and Gauguin were to share from October to December 1888. Rijksmuseum Vincent van Gogh, Amsterdam.

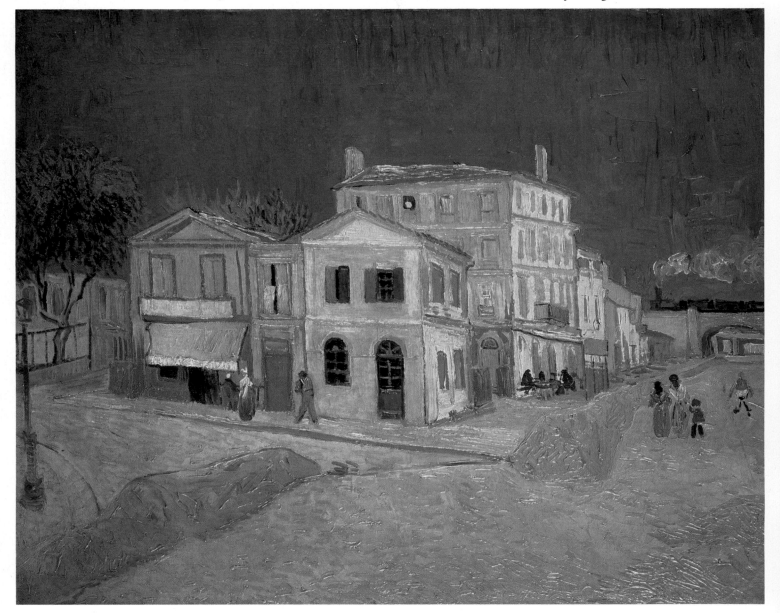

Memory of the Garden at Etten. November 1888. Here, under Gauguin's influence, Van Gogh attempted to paint from memory and imagination, evoking the parsonage at Etten and including portraits of his mother and sister. But he soon gave up this approach, feeling that he needed the stimulus of an on-the-spot subject to which he could respond directly. Hermitage Museum, Leningrad.

way, notably in *Memory of the Garden at Etten*, in which he included portraits of his mother and sister, but he soon decided that this 'enchanted territory' was in fact a dead end.

Without actually quarrelling, Gauguin and Van Gogh increasingly got on each other's nerves. The first open conflict seems to have occurred about the time Gauguin was finishing a portrait of his friend – a strange portrait in which Van Gogh, shown at his easel painting sunflowers, is given a long-jawed face and a disturbingly purblind look; he remarked, significantly, that he thought it like himself . . . but himself gone mad. One night in mid-December, when the two men had gone to the café together, Van Gogh suddenly flung his glass of absinthe at Gauguin, who managed to duck. According to Gauguin's later account, he at once took Van Gogh home and put him to bed; the next day Van Gogh had only a vague memory of the incident, but Gauguin felt it was dangerous to remain. He wrote to Theo announcing his imminent return to Paris: he had a high regard for Vincent, he said, but they were temperamentally incompatible. Vincent somehow persuaded Gauguin to stay after all; Gauguin wrote to a friend that he owed a great deal to the Van Goghs and was moved by Vincent, 'who is sick, who suffers, and who asks for me', although his departure remained a possibility. Van Gogh sensed as much, and seems to have lived in a state of perpetual tension, believing Gauguin might change his mind at any moment. His fears made him behave in a fashion calculated to bring about the very event he most dreaded. He became moody and silent, yet he was so anxious that at night he would wander over to Gauguin's bed to make sure he had not gone. When Gauguin threatened to leave, Van Gogh reacted still more strangely: he tore a sentence from a newspaper and put it in his friend's hand. It read: 'The murderer had fled.' The painting *His Empty Chair* is almost a visual equivalent to this view of things, another sinister study in reds and greens, the armchair

empty but for books and a candle in its holder. Van Gogh's sense of insecurity was probably heightened by the news that Theo had become engaged. Unconsciously, Vincent may well have been upset by the possibility that a wife and children would supplant him in Theo's affections, as well as making it impossible for him to continue subsidizing his brother; the marriage threatened both his financial and emotional supports.

The end came on the 23rd of December. Gauguin left the house in the evening and was walking across the square when he heard Van Gogh's footsteps behind him. He turned, and some kind of altercation took place. (Gauguin gave two accounts of the incident, the second of which has Van Gogh flourishing a razor at him. In the absence of other witnesses it is impossible to say which account is correct. Gauguin may have discreetly censored the earlier version; alternatively he may have been tempted to melodramatize the events in later life.) As a result, Gauguin decided to spend the night in a hotel. The distraught Van Gogh went back to the yellow house and hacked off a piece of his left ear with a razor; he may have been trying to silence voices in his head, or he may have had some idea of punishing Gauguin. Still bleeding profusely, he hid the wound under a large beret and walked to one of the town's licensed brothels; there he asked for a girl called Gaby and presented her with the piece of ear wrapped in newspaper, telling her to look after it carefully. The police were called in, and the following morning they went to the yellow house, where they discovered Van Gogh in a coma. Gauguin arrived shortly afterwards. According to his account (possibly

Vincent's Chair with his Pipe. December 1888–January 1889. For Van Gogh, objects had strong emotional associations with their owners. Here, he seems to be announcing his own openness and need; by contrast, the sinister colouring and the contents of *Gauguin's Armchair, Candle and Books* (opposite) suggest Gauguin's 'wickedness' and his impending desertion of Van Gogh. Tate Gallery, London.

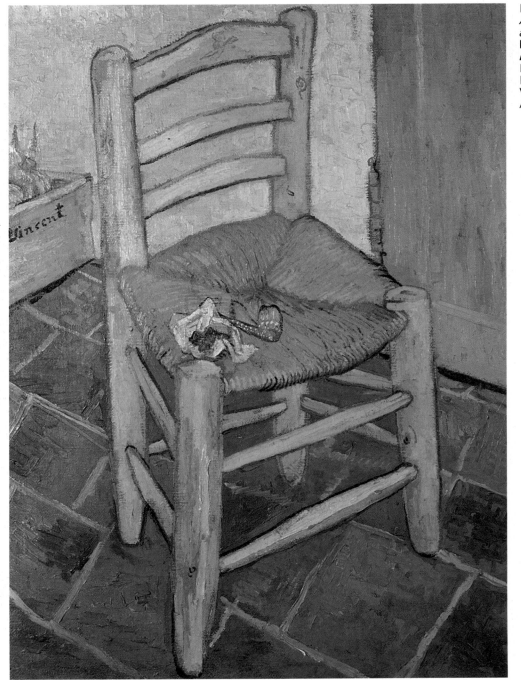

Right: *Gauguin's Armchair, Candle and Books* (also known as *His Empty Chair*). December 1888. Rijksmuseum Vincent van Gogh, Amsterdam.

64

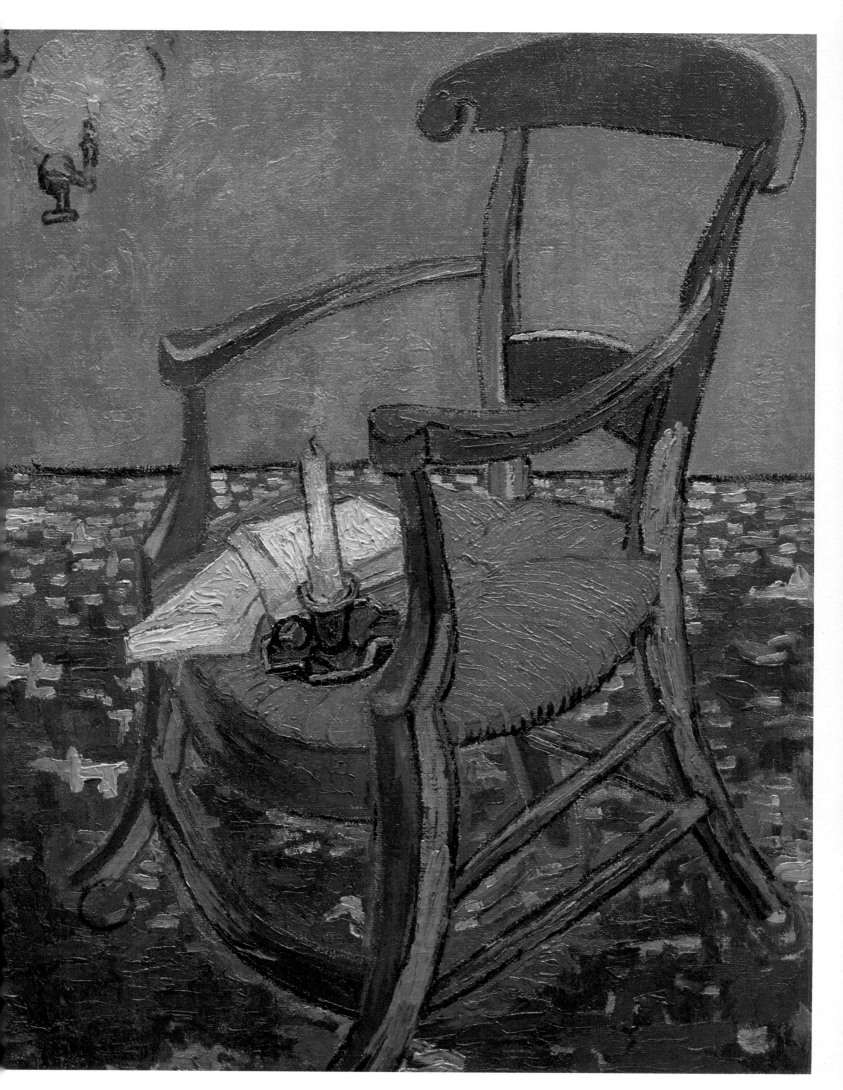

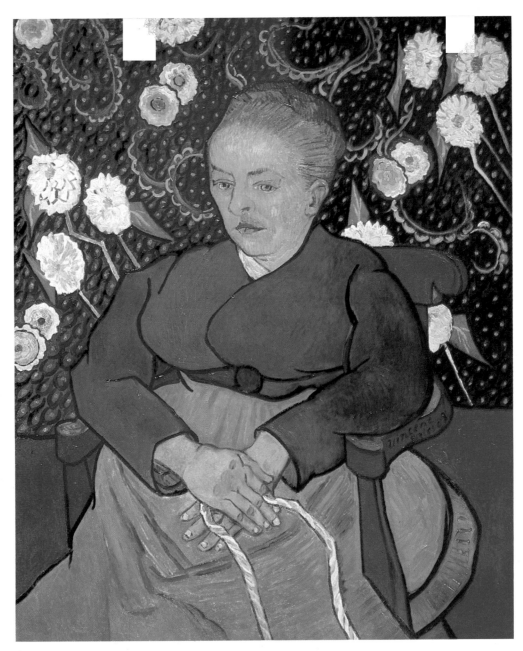

La Berceuse.
January 1889. One
of five portraits of
Madame Roulin,
wife of his friend,
the Arles postman
Armand Roulin. Van
Gogh painted it
between periods of
confinement in the
local hospital, and
the sense of
oppression in it is
unmistakable.
Walter H.
Annenberg.

embroidered, of course), he was confronted by a police officer who asked him without ceremony what he had done to his friend – who was dead. After he had denied the charge and recovered from the shock, Gauguin went to look at Van Gogh and found that he was still breathing. Then, telling himself that his presence could only upset Vincent, he hastily prepared to leave for Paris, meanwhile telegraphing Theo that he was urgently needed in Arles.

Theo came for a few days, though there was little enough he could do for his brother. Vincent was soon out of danger physically, but his mental recovery was slower; he was incoherently preoccupied with religious and philosophical ideas, and his impulse towards self-deprivation (or self-punishment) reasserted itself strongly. After a week or so he was lucid enough to write to Theo, and on the 7th of January he was released from hospital and taken home by his postman friend Roulin. But a month later he succumbed to another attack, this time in the form of persecution (he believed someone was trying to poison him), and had to be hospitalized again. He seemed to make a good recovery, but shortly after his release his neighbours petitioned the mayor to have him 'returned to his family' or sent back to hospital. According to the testimonies subsequently given to the police, Van Gogh touched women in the shops, made obscene remarks and insulted the customers. The charges may have been true, or may have been exaggerations designed to convince the police that Van Gogh was dangerous; what can scarcely be doubted is that people in the neighbourhood felt unsafe while he was in their midst. However, they may also have been partly to blame for his over-excitement, since their fear of him was combined with the cruel curiosity of simple minds, and both adults and children tormented him by climbing up the walls of the yellow house and spying on him through the windows.

The police concluded that he was potentially, though not actually, dangerous, and on 28 February an officer closed up the yellow house and escorted Van Gogh back to the hospital. The experience of incarceration brought on a new attack, and the prospects of a complete recovery began to seem more remote.

During his periods of freedom, Van Gogh had started to paint again. His *Self-portrait with Bandaged Ear* (Collection S. Niarchos, Athens) is a touching, stoical painting of the newly recovered Vincent in fur hat and greatcoat, puffing on his pipe; in this, and in another self-portrait (Courtauld Institute, London), the face is pinched and corpse-like. Other works included a portrait of Dr. Rey, a sympathetic physician attached to the hospital, and no less than five versions of *La Berceuse*, in which the postman's wife, Madame Roulin, rocks an invisible cradle; both paintings are notable for their dense decorative backgrounds, which contribute to their rather oppressive atmosphere.

After a month in hospital, Van Gogh was allowed to go out by himself, and he soon made a start on some paintings – the first of a group that capture, like nothing else before them, the desolation of institutional life. By this time he had become reconciled to leaving the yellow house, recognizing that he was in no condition to live on his own. Theo, newly married, was not anxious to have Vincent with him in Paris; he told his wife that the city had seriously over-excited his brother before, and gave a lucid description of Vincent's eccentricity and turbulent, intemperate way of handling his personal relationships. When he did offer to bring Vincent to Paris or Pont-Aven, Vincent declined. He now wanted to be as little trouble as possible, and even suggested that since he was feeling physically very strong he should sign on with the French Foreign Legion for five years. The alternative, to which he readily agreed, was to live under care in an asylum. A place was found for him at Saint-Rémy, about twenty-seven kilometres from Arles, and on 8 May 1889, accompanied by his friend Pastor Salles of the Arles hospital, he went to the asylum and committed himself.

Madame Roulin and her Baby. November–December 1888. Painted at Arles. Lehman Collection, New York.

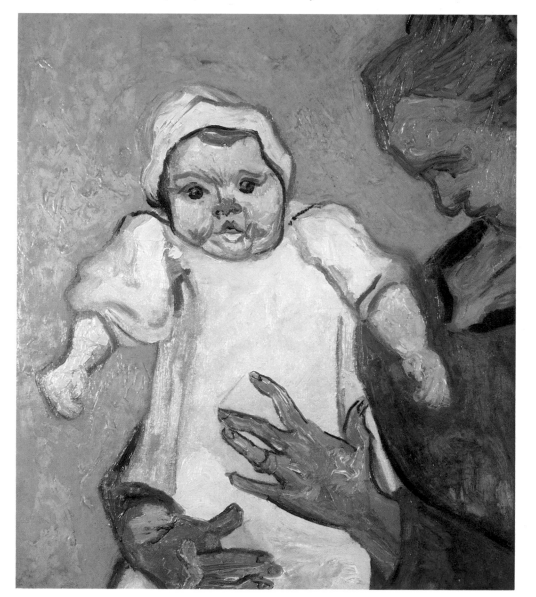

The Unbearable Vision

Saint Paul's Hospital was situated in the countryside outside Saint-Rémy, about three kilometres away from the town. It had been an Augustinian monastery until the beginning of the century, when it had been converted into an asylum by the addition of two long wings. When Van Gogh arrived it was a rather gloomy, rundown establishment. There were only ten other patients in the men's wing, the individual rooms were depressingly like cells, and the common room for use during bad weather reminded Van Gogh of a third-class waiting-room; some of the inmates even dressed in travelling outfits, as if pathetically deluded that they were in transit to some other destination. The corridors were memorably recorded in a watercolour by Van Gogh, who emphasized their empty-box-like character and apparently infinite extent. The head of the asylum, Dr. Peyron, seems to have been perfunctory and parsimonious: treatment consisted of two baths a week, and the food was so bad that Van Gogh refused it in favour of bread and soup. But at first he remained in good spirits, since he regarded his stay at Saint-Rémy as a rest cure rather than the occasion for a course of treatment.

All the same, in the works associated with the asylum – beautiful, detailed flower studies, pulsatingly vivid drawings and paintings of the garden – the sky is almost entirely suppressed and there is a sense of being overwhelmed by objects, as if one were standing too close to them. This particular form of oppressiveness is absent from the works executed in the countryside around the asylum. By early June, Van Gogh was judged fit to go out in the company of a guard, and some of his most inspired painting was done in the cornfields, olive groves, vineyards and rocky places of the area. His style now assumed its most distinctive character, with violently undulating lines used to give an impression of swirling, heaving, billowing, flaring or buckling; in these landscapes (the word seems rather feeble in this context) every inch of earth and sky is seething with dangerous life. In his hands the cypress, previously shown in art as a solemn, funereal tree, became 'the black spot in a sunlit landscape'; Van Gogh was understandably proud of being the first painter to have exploited its almost

Below: *The Vestibule of Saint Paul's Hospital*. May or early June 1889. Black chalk and gouache. Rijksmuseum Vincent van Gogh, Amsterdam.

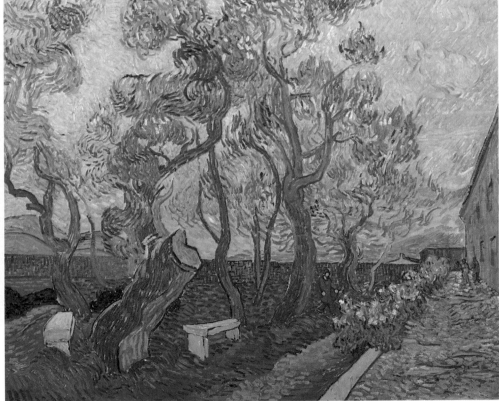

Right: *The Garden of the Hospital at Saint-Rémy*. 1889. Folkwang Museum, Essen.

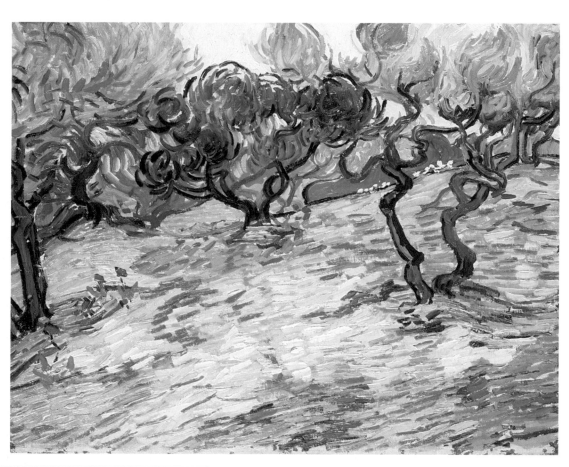

Right: *Olive Trees*. 1889. Painted at Saint-Rémy. The writhing olives and brilliant blossoms might be symbols of genius at the end of its tether. National Gallery of Scotland, Edinburgh.

Below: *The Hospital at Arles*. 1889. This was begun at Arles and finished in the asylum at Saint-Rémy. Like the paintings on the opposite page, it conveys a fearful sense of institutional desolation. Oskar Reinhart Collection, 'Am Römerholz', Winterthur.

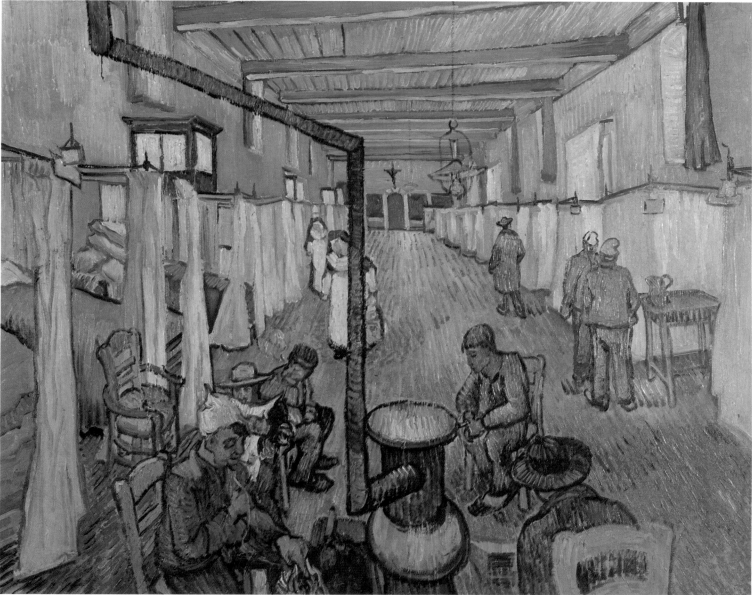

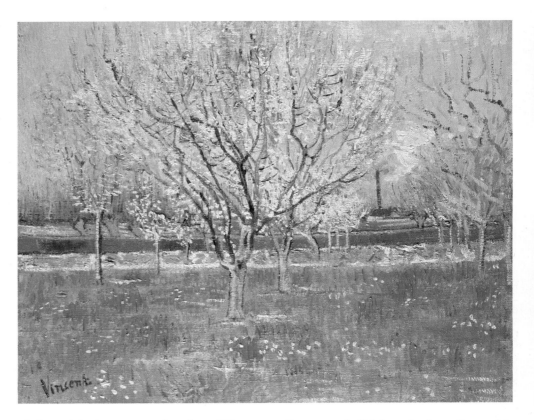

Right: *Orchard in Blossom*. 1889. Painted at Saint-Rémy. National Gallery of Scotland, Edinburgh.

Cypresses. June 1889. An example of the extraordinary effects Van Gogh obtained with the reed pen. The tormented, flame-like lines of the cypress often appear in his later work. Brooklyn Museum, New York.

sinister black-green colouring. The most famous of all his paintings from this great creative period of June and early July 1889 is *Starry Night*, its sky crowded with mysterious flowing lines, suggestive of galaxies in motion, and stars like fireballs that might well be plunging into the sleeping town below.

On Van Gogh's arrival at the asylum, Dr. Peyron diagnosed his malady as epilepsy. He was certainly right, although there were probably several contributory or complicating factors that are impossible to evaluate at this distance in time; among those that have plausibly been suggested are malnutrition, alcoholism, syphilis and schizophrenia. The presence of psychological factors is confirmed by the relationship between Van Gogh's attacks and events in Theo's family life. The first set of attacks, in Arles, occurred just after Theo had announced his engagement; the next really serious one came on 10 July 1889, a few days after Vincent learned that Theo's wife Joanna was pregnant. During his seizures, Van Gogh experienced terrifying hallucinations and suicidal impulses, and afterwards he remained in a state of torpor for some time. The very severe attack in July left him prostrate and afraid to leave the asylum building until September. He had been painting outdoors when the fit came on, and from this time displayed a certain nervousness about working in the countryside; to judge from remarks in his letters, on such occasions he felt a particularly desolating sense of isolation under the open sky.

Between attacks, Van Gogh was lucid and almost entirely normal. As his hopes of a permanent recovery faded, he accepted with fortitude that he would be laid low every few months and must accomplish what he could in the intervals. One of the self-portraits he painted after his recovery, in the autumn of 1889, is an almost glamorous image of the artist with brushes and palette. He persuaded the chief attendant, Trabu, to sit for an equally elegant portrait, but he seems to have steered clear of the other inmates of Saint-Rémy. A lack of human subjects may have encouraged him to begin extensive copying of other masters' works at this time; no doubt the practice was also beneficial in enabling him to work self-forgetfully indoors when he was feeling particularly nervous, and there may also have been an element of retrospective self-appraisal involved. He copied Delacroix, Daumier and above all his old hero, Millet, whose influence on him had been slight since his departure from Holland; his tastes, even the colours he used, reverted to those days for a time. Van Gogh seems to have tried to copy as faithfully as possible, but his own powerful style is always in evidence (which is, of course, what gives the copies their considerable interest for us); the colours, too, are his – inevitably, since (this being before the age of colour photography) he was working from black and white prints.

In January 1890, Vincent van Gogh's work at last began to attract some attention. The critic Albert Aurier made him the subject of a long, rather over-

Right: *Starry Night*. June 1889. In this drawing (now lost) Van Gogh used a reed pen and Chinese ink to reproduce the vertiginous effects of the famous painting on the same subject. Ex Kunsthalle, Bremen.

Below: *The Stone Bench in the Garden of Saint Paul's Hospital*. October 1889. Museu de Arte de São Paulo.

Right: Black crayon studies of hands and for *The Sower*. 1890. Vincent van Gogh Foundation, Amsterdam.

Above: A plant study done with a reed pen. *c.* 1889—90. Vincent van Gogh Foundation, Amsterdam.

Above right: *Four Men on the Road.* 1890. In this black crayon study the men resemble institutionalized patients or criminals, faceless and apparently uniformed. Vincent van Gogh Foundation, Amsterdam.

blown but insightful article, 'Les Isolés: Vincent van Gogh', in the journal *Mercure de France*, and the avant-garde Belgian group Les Vingt invited him to exhibit at their show in Brussels. Theo sent them a number of Vincent's paintings, which stirred up some controversy: a Belgian painter, Henri de Groux, denounced them and as a result was almost involved in a duel with Van Gogh's friend, Toulouse-Lautrec. At the exhibition itself, Van Gogh made his first sale in the public world of exhibitions and auctions: the painter Anna Boch, sister of the 'poet' whose portrait he had painted at Arles, bought *The Red Vineyard* for 400 francs. Two months later, ten of his paintings were shown at the exhibition organized by the Salon des Indépendents. This was in no sense a popular success, but it represented a significant degree of recognition by his fellow-artists. Pissaro and others examined the canvases by Van Gogh stored in Paris at Père Tanguy's; Gauguin wrote from Pont-Aven to congratulate and praise him. (Van Gogh had resented Gauguin's 'desertion' and his not unreasonable decision to telegraph Theo, but the two men remained friendly and corresponded from time to time.)

Right: *The Schoolboy*. 1890. Museu de Arte de São Paulo.

Below: *Branch of an Almond Tree in Blossom*. February 1890. Painted and sent as a form of congratulations to Joanna van Gogh, wife of Vincent's brother Theo: she had just given birth to a son. Rijksmuseum Vincent van Gogh, Amsterdam.

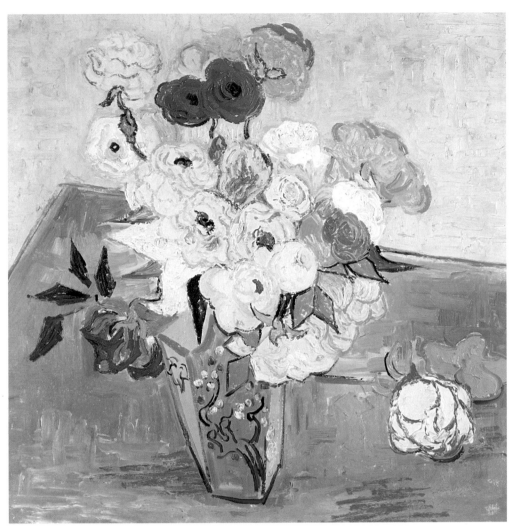

Right: *Roses and Anemones*. 1890. Musée du Louvre, Paris.

Below: *Meadow with Butterflies*. 1890. National Gallery, London.

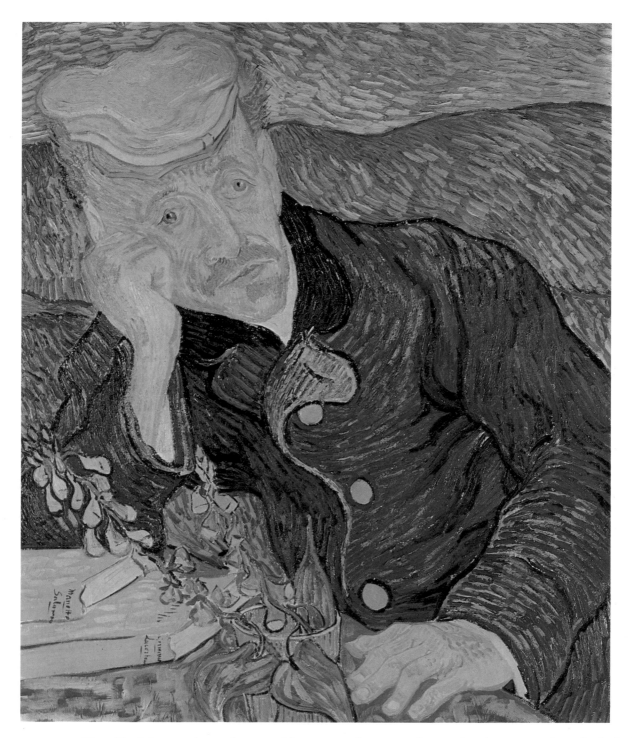

Van Gogh's reactions alternated between pleasure at becoming known and a masochistic rejection of it. In any case, his personal affliction was more immediately important. After three months of good health, two quite mild attacks in December 1889 and January 1890 led him to hope that he was beginning to get better. Then, at the end of February, he had a devastating seizure, worse than anything before, in which he tried to poison himself by swallowing his paints. Significantly, this occurred shortly after Joanna van Gogh gave birth to a son – although consciously Vincent was moved and delighted, sending them a charming painting of a branch with almond blossoms to celebrate the event.

Van Gogh had been thinking of leaving Saint-Rémy for some time; he had suggested joining Gauguin in Brittany, receiving a friendly answer that may have been a deliberate – understandable – evasion: the isolation would not suit Vincent, but perhaps they could share a studio in Antwerp . . . Van Gogh's seizure in February convinced him that he would not recover at Saint-Rémy and would therefore be better off in the North, nearer Theo and his family. When he had recovered, he arranged to leave the asylum. The arrival of fresh painting materials stimulated him to create a series of superb still lifes with roses and irises; then, on 16 May 1890, he left Saint-Rémy for Paris. His entry in Dr. Peyron's register is contradictory: one column gives a brief history of his illness, noting that he was settling in the North of France in the hope that the climate

Portrait of Dr. Gachet. Gachet, who exercised a general supervision over the painter during his last months, was himself a strange, eccentric being; here Van Gogh has given him 'the sad expression of our time'. June 1890. Private New York collection.

Far right: *The Church at Auvers*. June 1890. The most mind-staggering of all Van Gogh's Auvers paintings: the solid little church, the very image of stability and continuity, rocks and buckles as if pressed down by the weight of the sky or moved about by an upheaval of the earth itself. Musée du Louvre, Paris.

Right: *Child with an Orange*. 1890. Private collection, Winterthur.

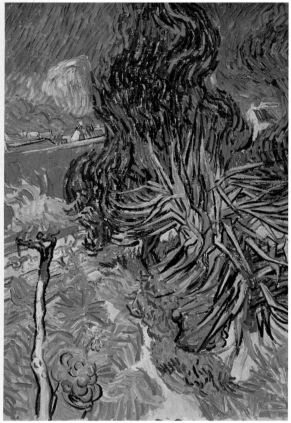

Above: *Dr. Gachet's Garden*. 1890. The order of a private garden is here transformed into a brilliant image of mental intensity. Musée du Louvre, Paris.

would help him; the other column contains the single word 'Cured'.

Insisting that he was perfectly capable of living an ordinary life between seizures, Van Gogh travelled to Paris on his own. In fact, however, anything but the quietest of situations now tended to upset him (several of his attacks at Saint-Rémy had been brought on by brief visits to Arles). After only four days in Paris with Theo and his family, he was glad to leave for Auvers, a little town outside the capital. Theo had arranged that Vincent should stay there, boarding at an inn, under the general supervision of a local physician, Dr. Paul Gachet. The choice of overseer seemed a good one, for Gachet was a passionate enthusiast for art whose house was filled with paintings by Renoir, Pissarro, Cézanne and other modern masters. After a discussion of artists they both admired, Van Gogh warmed to Gachet, and arranged to paint his portrait; the result pleased the doctor so much that he asked for a second version to be made. Van Gogh wrote to Gauguin that he had given Gachet 'the sad expression of our time', and indeed the portrait is all the more effective for the modernity, even casualness, of Gachet's white cap and blue coat. Van Gogh made his only etching, another portrait of Gachet, at the doctor's house, where there was a press on which to print copies from the copper plate. (The process involves 'drawing' in acid on the copper plate, which is then inked and wiped over so that only the acid-bitten areas retain the ink and will print when the plate is pressed onto paper.)

At Auvers, a pretty spot where Pissarro and Cézanne had worked years before, Van Gogh was happy and incredibly, dangerously productive; as at Arles, he painted one or more canvases on most days, ardently recording the flowering chestnut trees, little houses and wide fields. A work such as *The Church at Auvers* is almost frightening in its intensity: the harmless paths round the church become snake-like, and Van Gogh transforms the solid, ordinary, modest building into a suffering mass that appears to be buckling under the tremendous pressure of the sky.

By early July the pressures had indeed started to build up. Theo was worried about his baby's health and was getting on so badly with his superiors (who had no faith in his 'modern' tastes) that he contemplated setting up on his own. The fact that he confided in Vincent suggests that not all the psychological difficulties

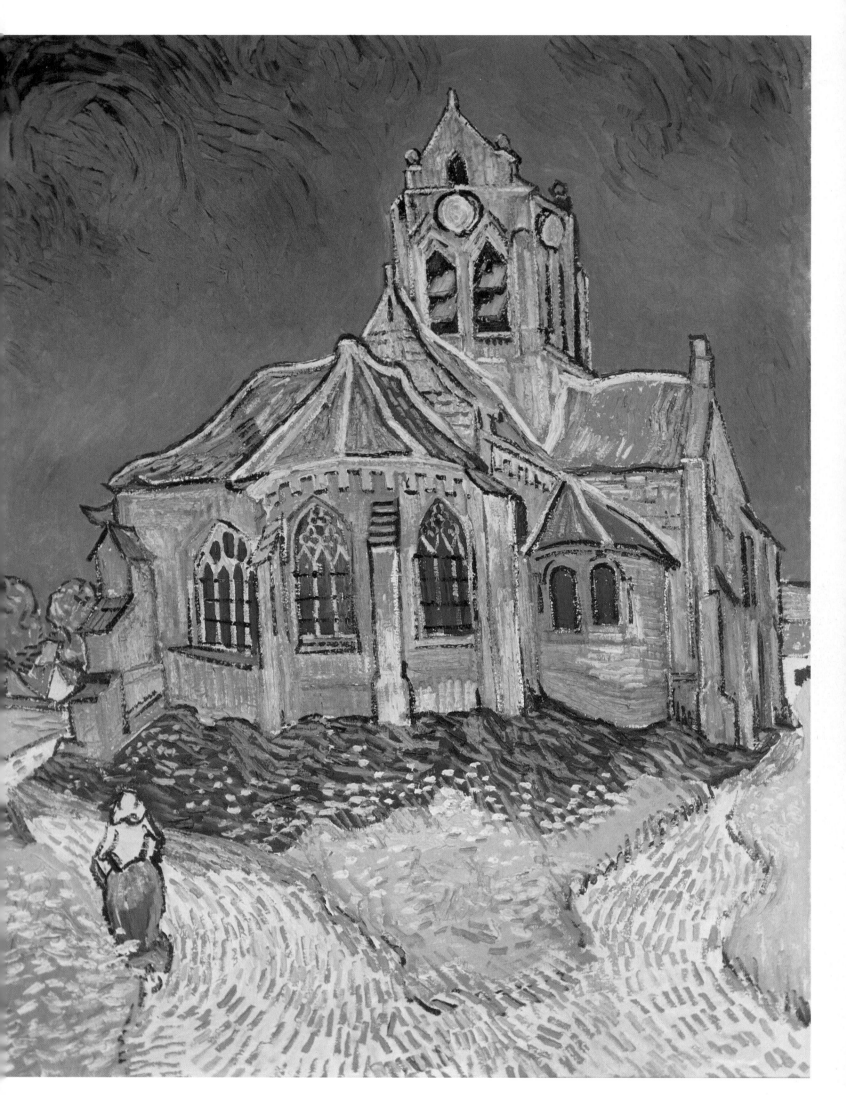

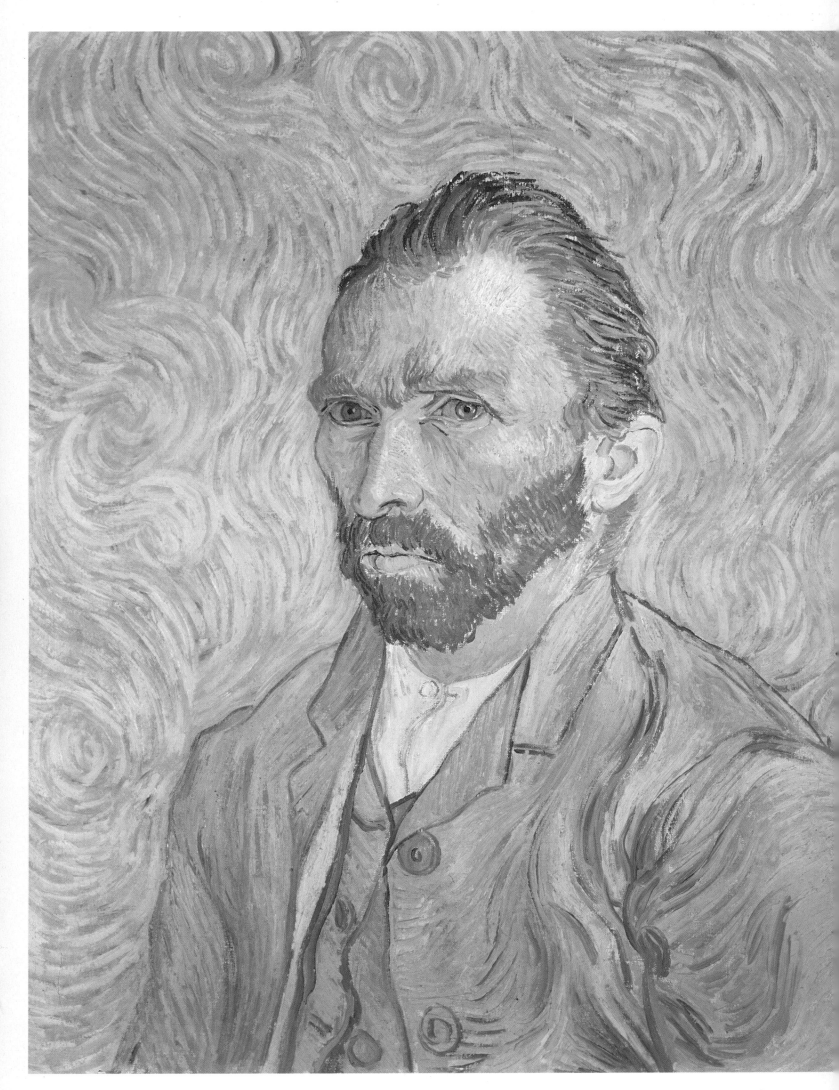

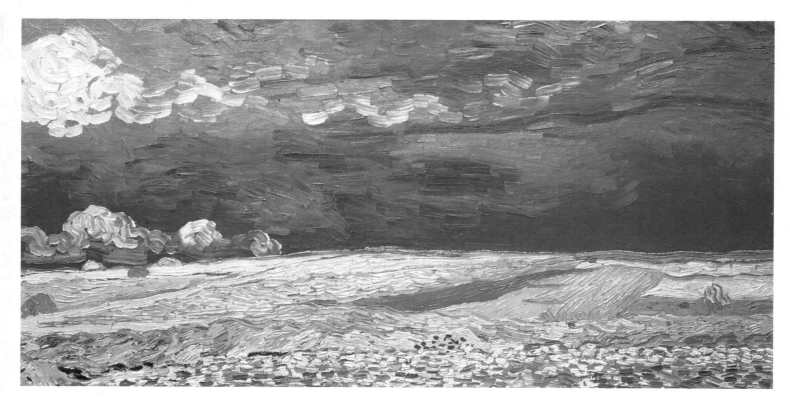

Above: *Field Beneath Thunderclouds*. 1890. As the final crisis approached, Van Gogh painted the plain around Auvers as a fearful, vast and sinister place. Rijksmuseum Vincent van Gogh, Amsterdam.

in the brothers' relationship were on one side: as might have been predicted, Vincent felt guilty about being a burden on his brother, and began to show signs of strain. Early in July he visited Theo in Paris and found him depressed; after he had received a visit from Aurier and lunched with Lautrec, he fled back to Auvers in a state of emotional exhaustion.

Over the next few weeks, the ominous signs multiplied. Van Gogh quarrelled with Dr. Gachet because he considered a nude by Guillaumin inadequately framed. He wrote incoherently and pessimistically to Theo. And again and again he painted the plain of Auvers as vast and sinister, threatened by turbulent skies or infested with crows. On Sunday, 27 July he began a letter to Theo, but he never finished it. Instead, as evening came on, he went out in the fields and shot himself. The bullet went into his chest below the heart, and he was able to stagger back to his room at the inn, concealing the wound; only when the innkeeper, Ravoux, insisted that he should get up from his bed did he admit what he had done. Even then, he refused to reveal his brother's address, and Ravoux had to leave a message at the gallery, which Theo received only when he arrived for work on the Monday morning. He rushed to Vincent's bedside, and for a time believed that he might recover. But Vincent was determined to die: 'The sadness will last forever,' he said. He died in Theo's arms on 29 July 1890.

The curious, symbiotic relationship between the brothers persisted after Vincent's death. Theo tried without success to arrange a memorial exhibition, threw up his job, began to behave erratically, and became first violently and later apathetically insane. He died on 25 January 1891, less than six months after Vincent. Both brothers are now buried in the cemetery at Auvers.

Left: *Self-portrait*. *c.* 1889–90. Musée du Louvre, Paris.

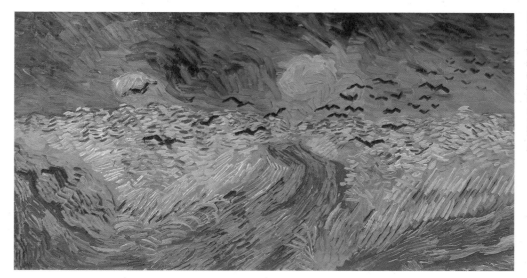

Left: *Crows in the Wheatfields*. 1890. In Van Gogh's last work the crows seem like harbingers of doom, the only speaking presence in a vast, deserted universe. Rijksmuseum Vincent van Gogh, Amsterdam.

Acknowledgments

Amon Carter Museum of Western Art, Fort Worth, Texas 38 top; Art Gallery and Museum, Glasgow 35 left; Bayerische Staatsgemäldesammlungen, Munich 50, 55; Bibliothèque Nationale, Paris 19 right; Boymans-van Beuningen Museum, Rotterdam 30; British Museum, London 57; Brooklyn Museum, New York 70 bottom; Courtauld Institute Galleries, London 7, 56; Photographie Giraudon, Paris 34 top, 36 bottom left, 37 right, 43, 53 bottom, 58, 61, 67, 68 right, 71 bottom, 73 top, 74 top, 76 top, 76 bottom left, 78, back cover; Hamlyn Group – Photographic Services, Edinburgh 29, 69 top, Hamlyn Group – Tom Scott, Edinburgh 70 top; Hamlyn Group Picture Library 12 left, 23 top, 36 top, 38 bottom, 47 right, 60 top left, 64, 66; Hermitage Museum, Leningrad 63; Kunsthalle Bremen 71 top; Musées Nationaux, Paris 37 left, 41, 48, 60 right, 77; Musée Rodin, Paris 51; Museum and Art Gallery, Walsall 23 right; National Gallery, London title page, 54, 74 bottom; National Galleries of Scotland, Edinburgh 47 left, 60 bottom left; New York Graphic Society, New York 11; Ny Carlsberg Glyptotek, Copenhagen 42; Oskar Reinhart Collection, 'Am Römerholz', Winterthur 69 bottom; Rijksmuseum Kröller-Müller, Otterlo front cover, 6, 8, 10, 12 bottom, 13, 16, 17, 18, 20, 21 bottom, 22, 24, 27 left, 27 right, 31 top, 52, 53 top; Stedelijk Museum, Amsterdam 8–9, 14, 15, 19 left, 21 right, 25, 26, 28, 31 bottom, 32, 33, 34 left, 35 right, 39, 40 bottom, 45, 46, 49, 59, 62, 65, 68 left, 72 left, 72 top right, 72 bottom right, 73 bottom, 79 top, 79 bottom; University of London, Courtauld Institute 44; Yale University Art Gallery, New Haven, Connecticut endpapers, 40 top.

©S.P.A.D.E.M., Paris (1982) 60 top left.

Front cover: *The Café Terrace on the Place du Forum, Arles, at Night.* September 1888. Rijksmuseum Kröller-Müller, Otterlo.
Back cover: *Le Père Tanguy.* 1887. Musée Rodin, Paris. (Giraudon)
Endpapers: *The Night Café on the Place Lamartine, Arles.* September 1888. Yale University Art Gallery.
Title spread: *A Cornfield with Cypresses.* 1889. National Gallery, London.

Note In 1986 the Musée d'Orsay in Paris was opened. This museum is now assembling under one roof works by French artists dating from the middle of the last century to 1914 from collections in the Louvre, Musée Nationale d'Art Moderne and elsewhere. Some of the works in this book may now be seen there.

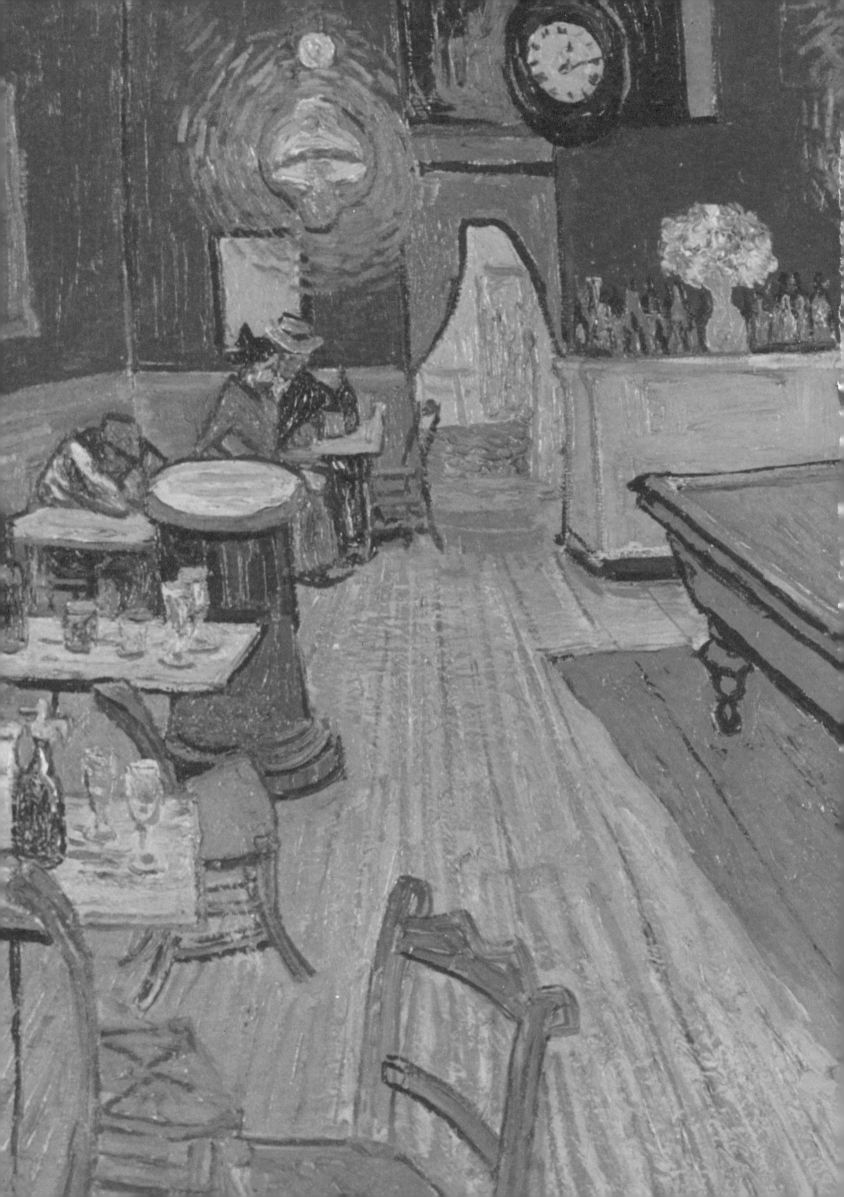